Easy Adult Coloring Book for Seniors

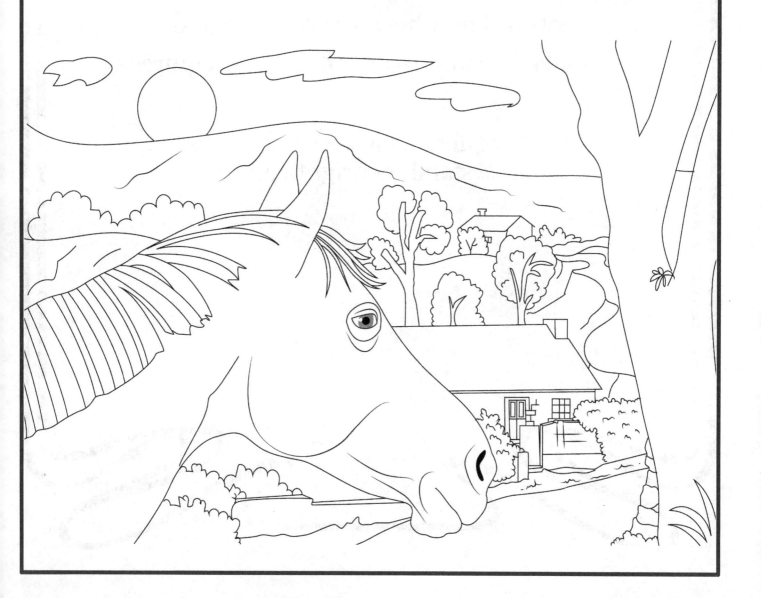

Hello!

Many thanks for your purchase and we hope that you enjoy this book.

You are most welcome to leave a review as it lets us know how we are doing and make any improvements where required.

For all inquiries, please send an email to info@starshinebright.com.au.

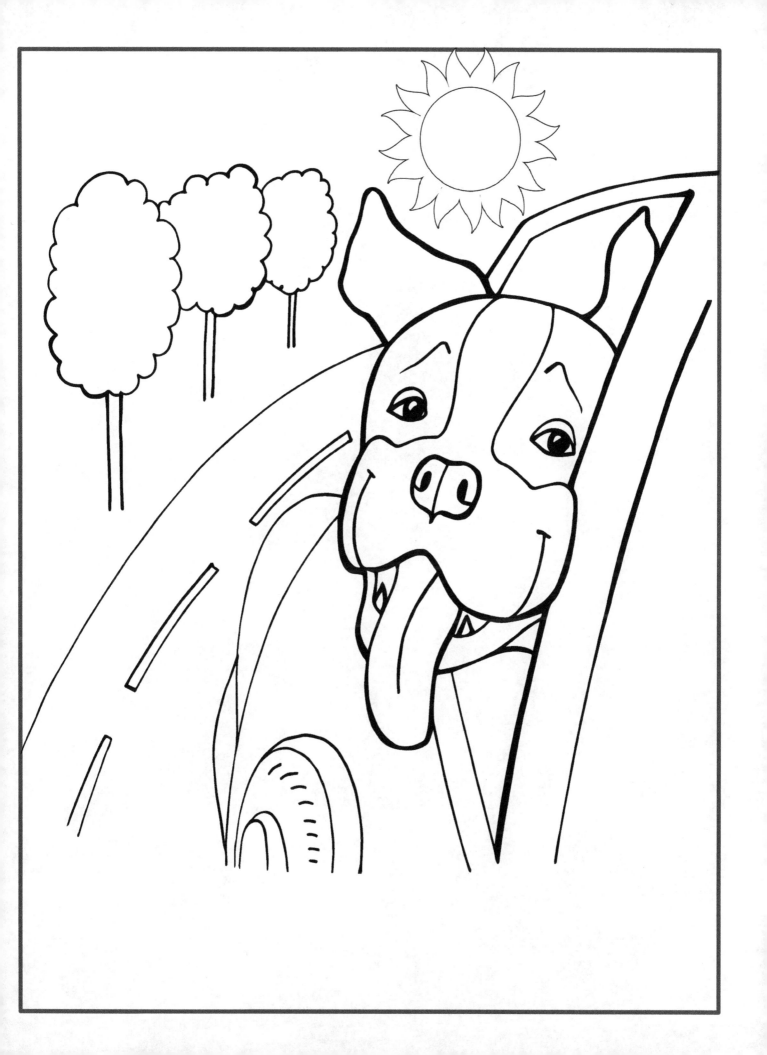

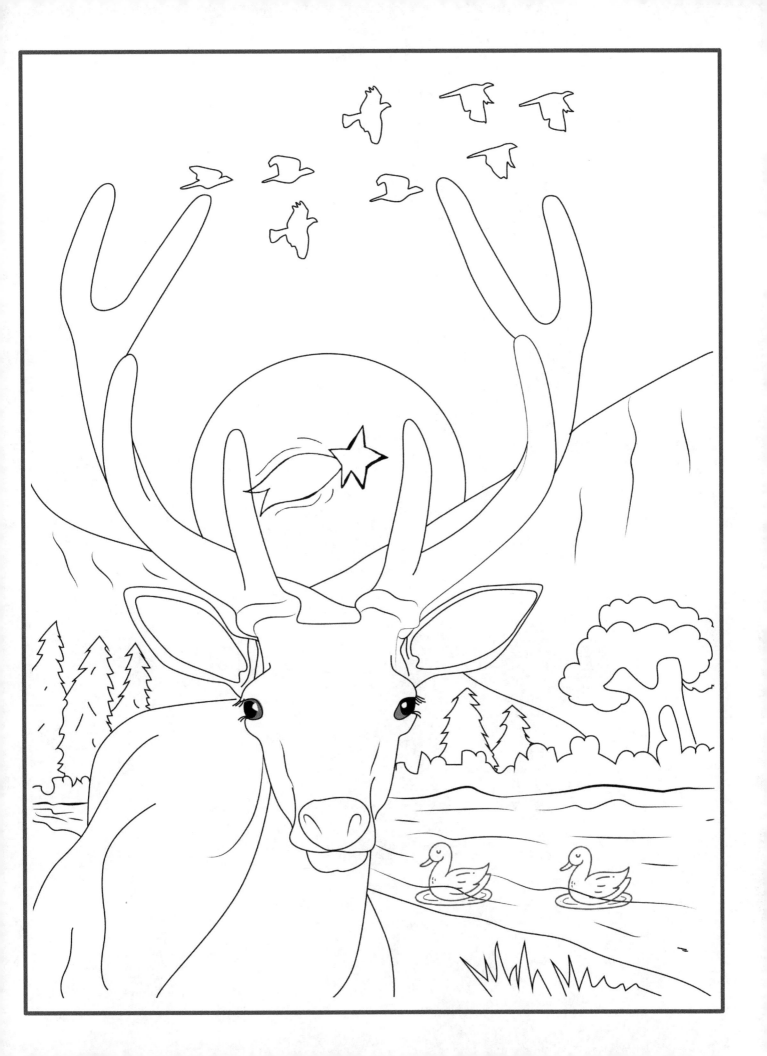

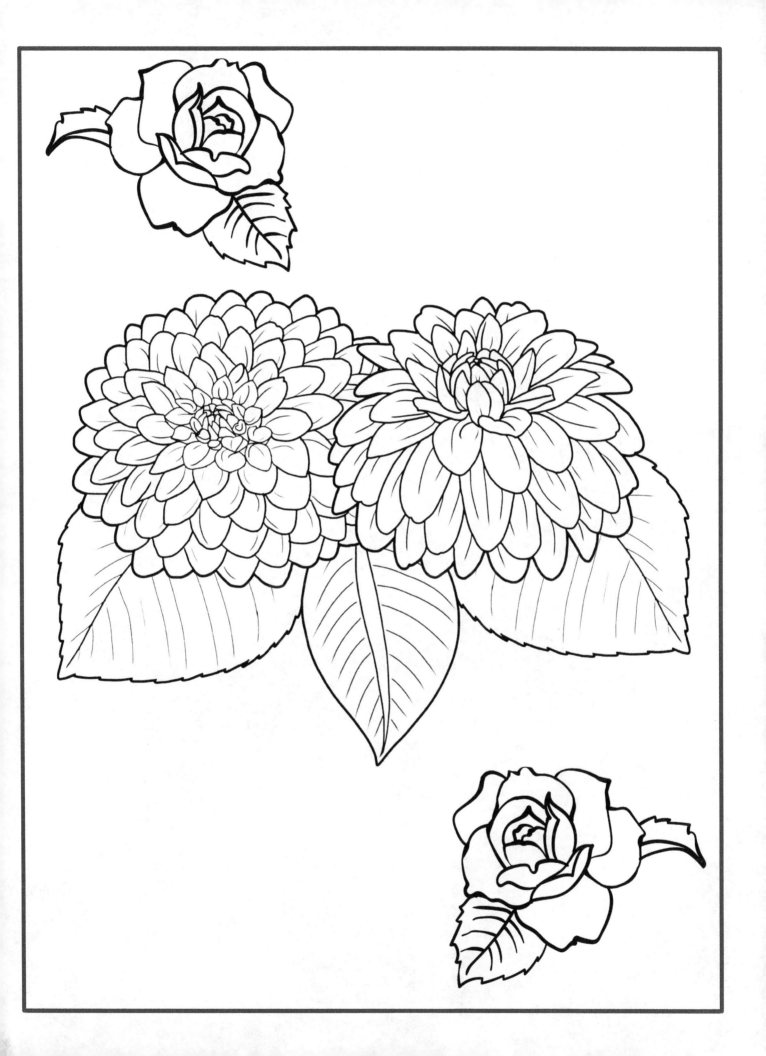

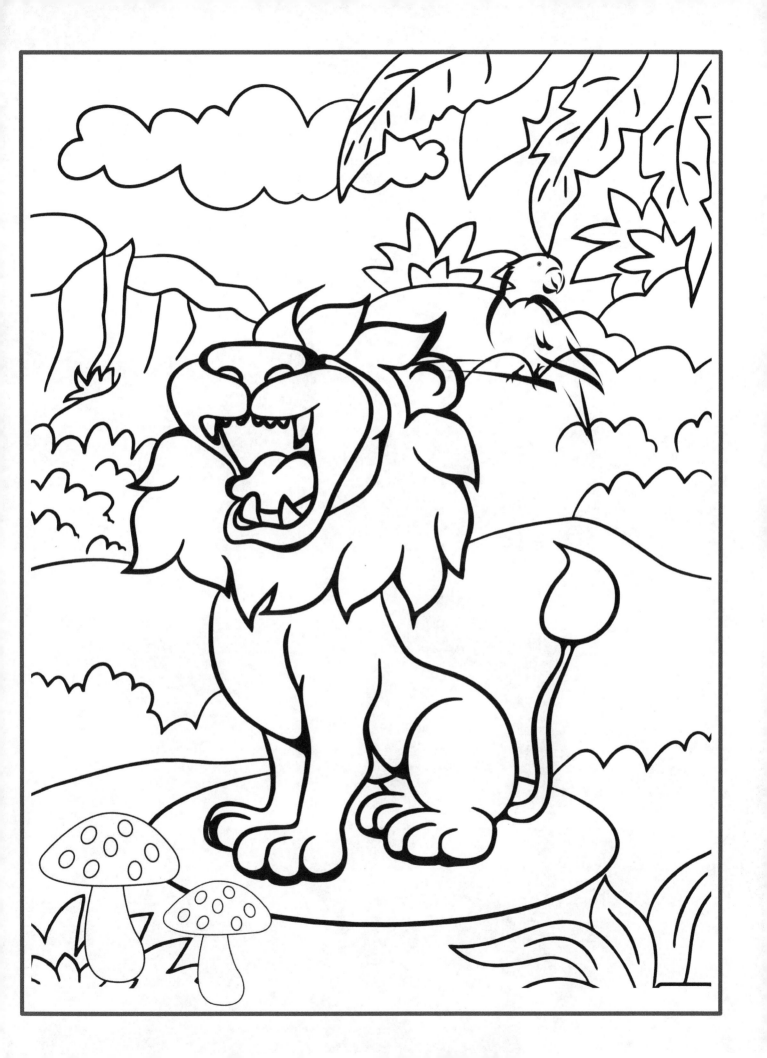

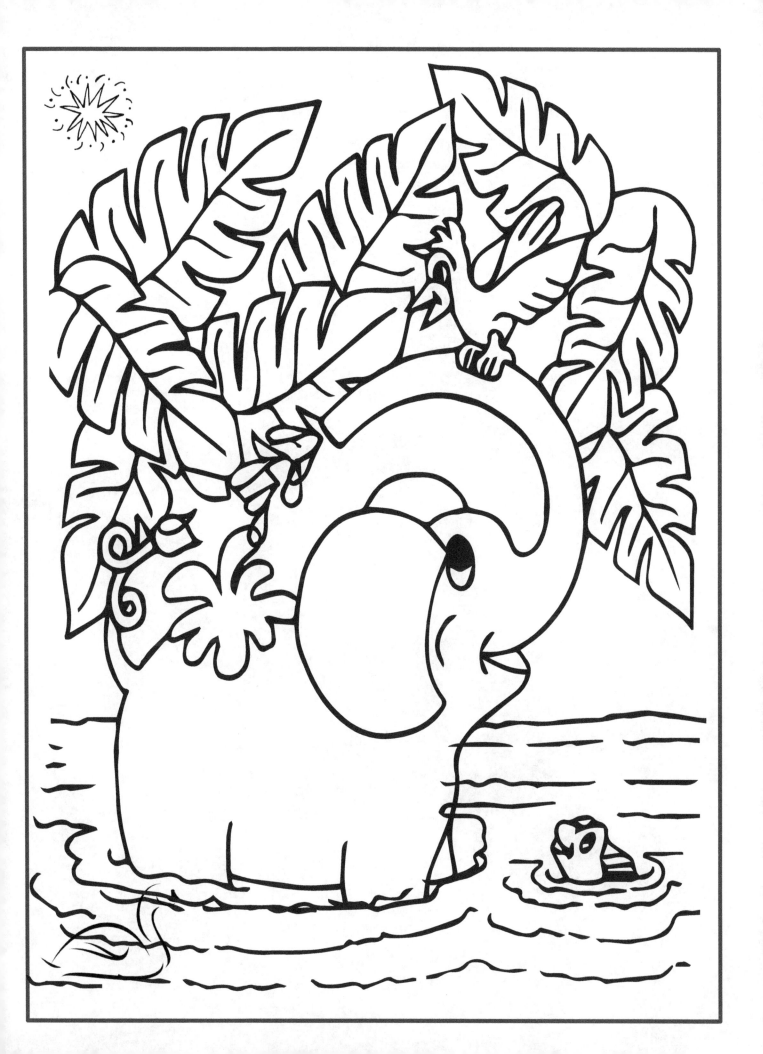

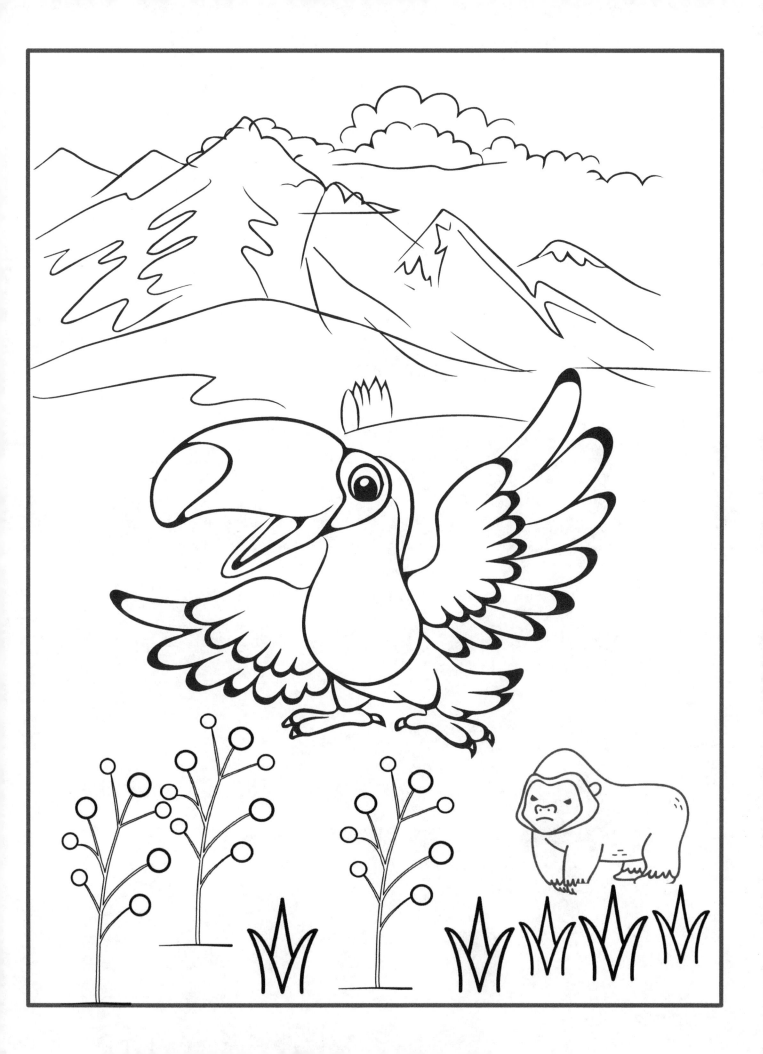

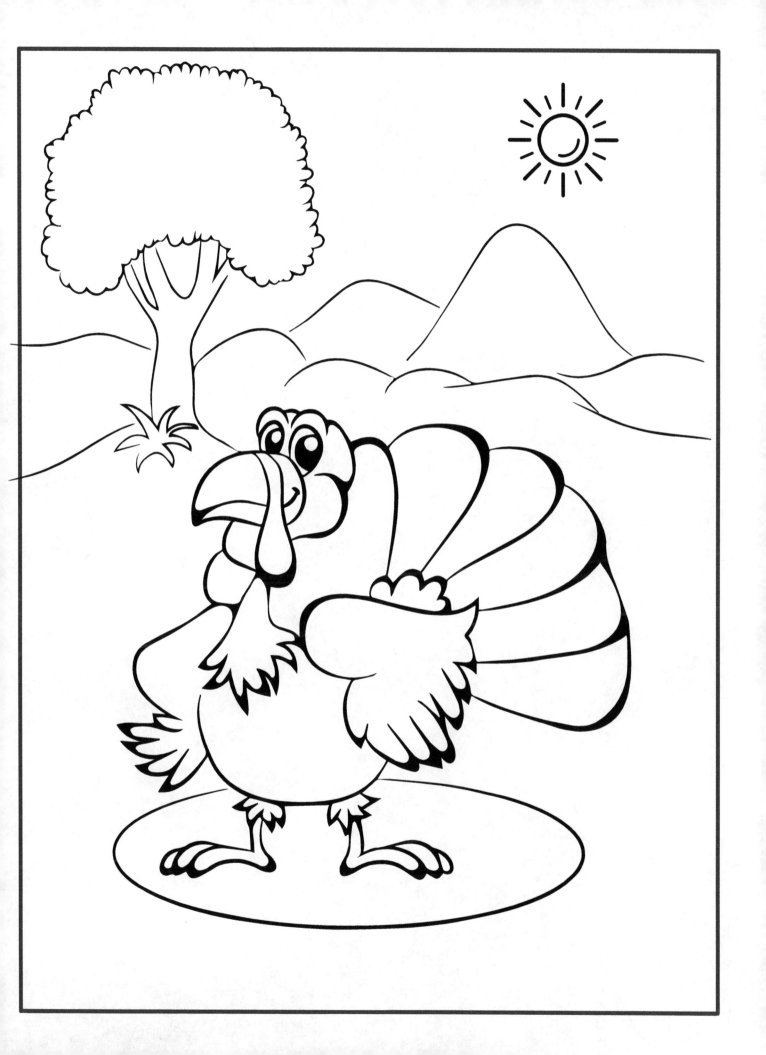

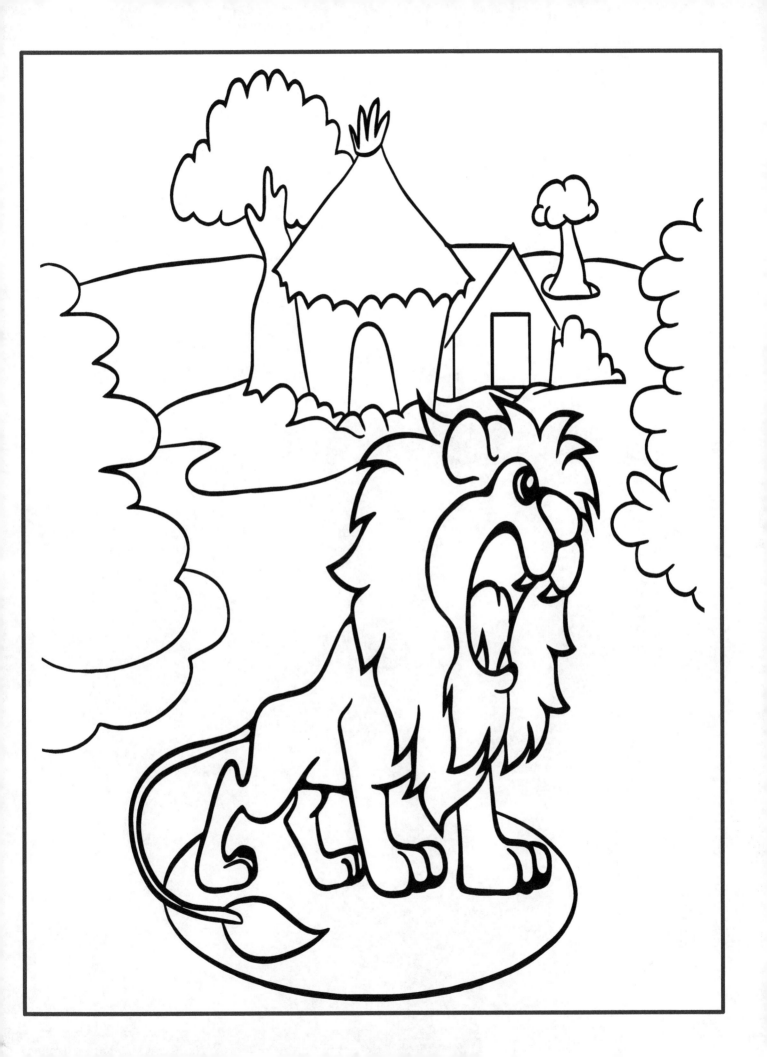

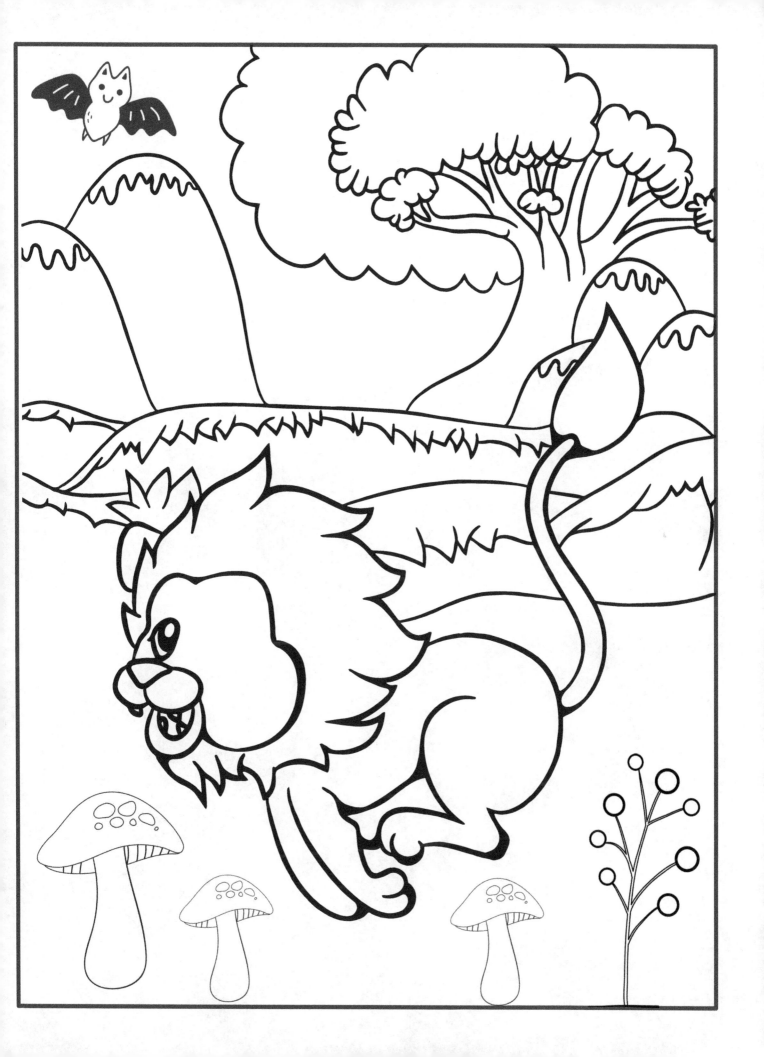

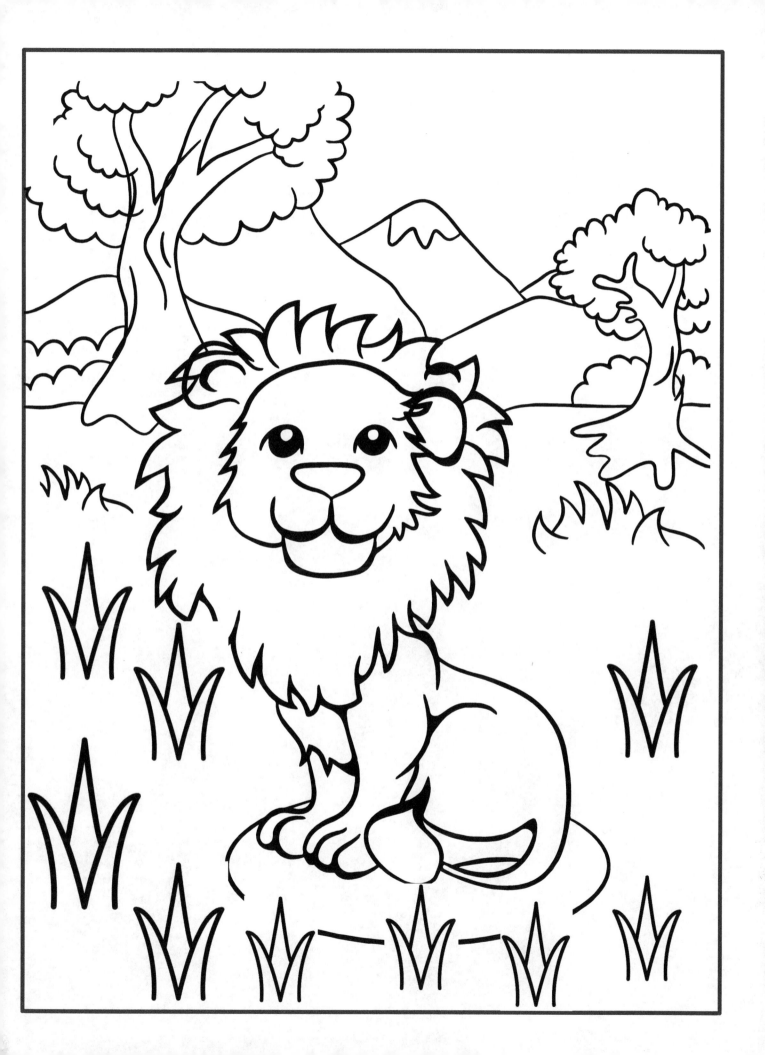

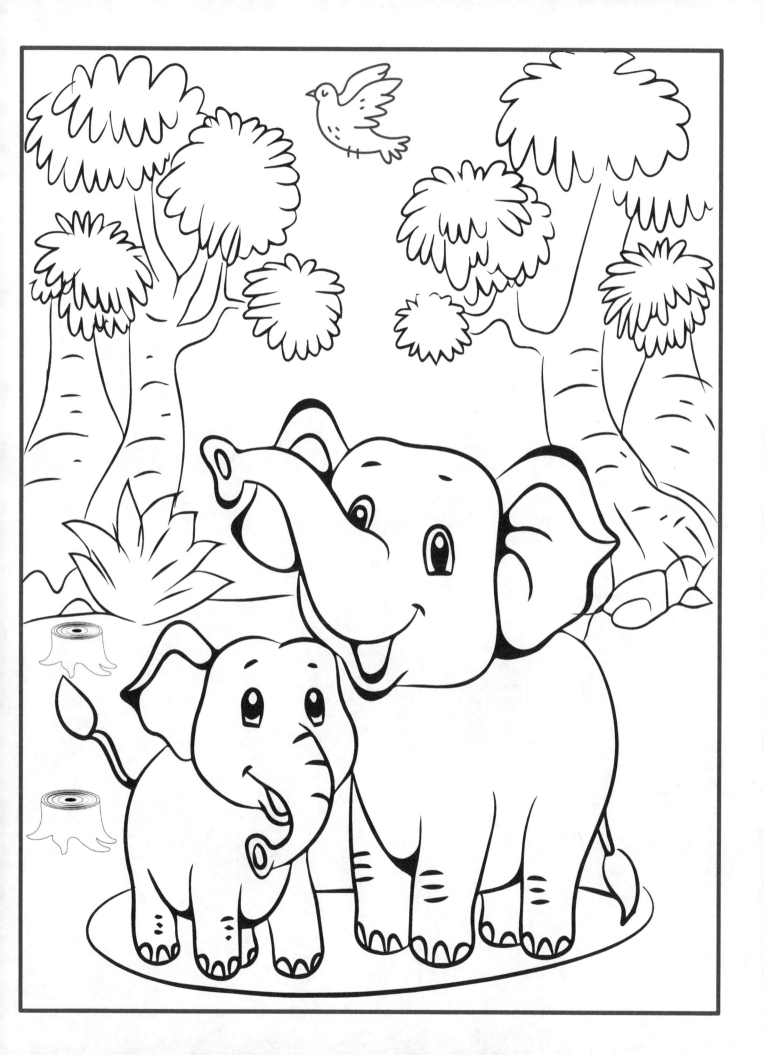

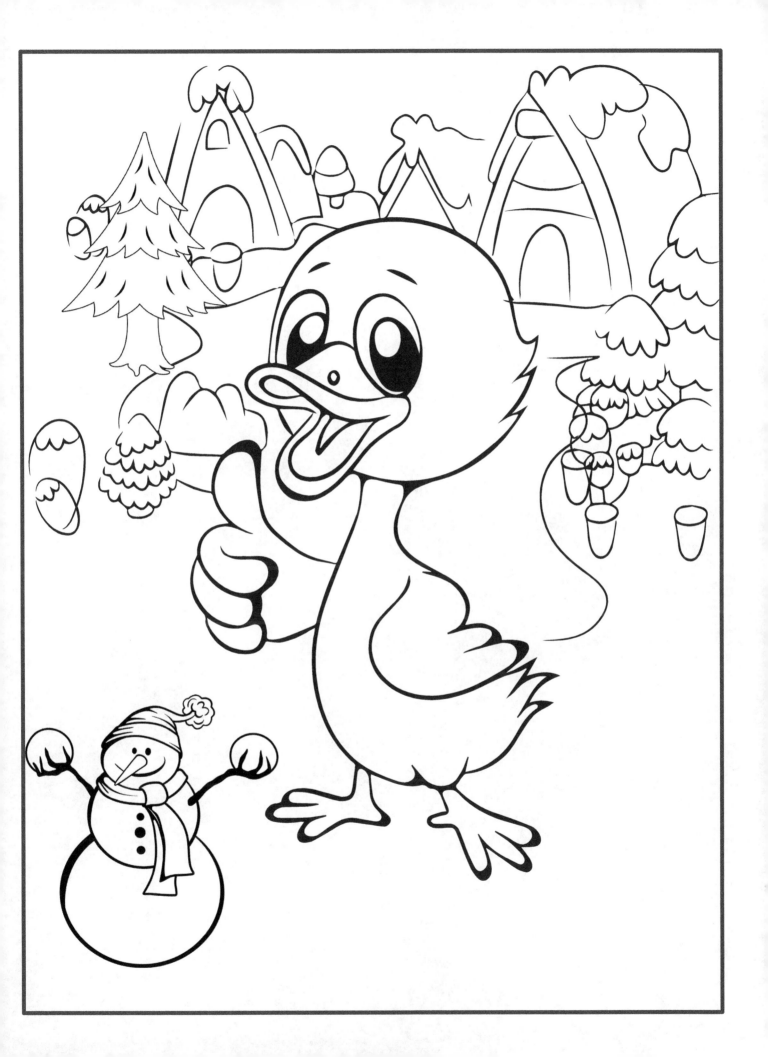

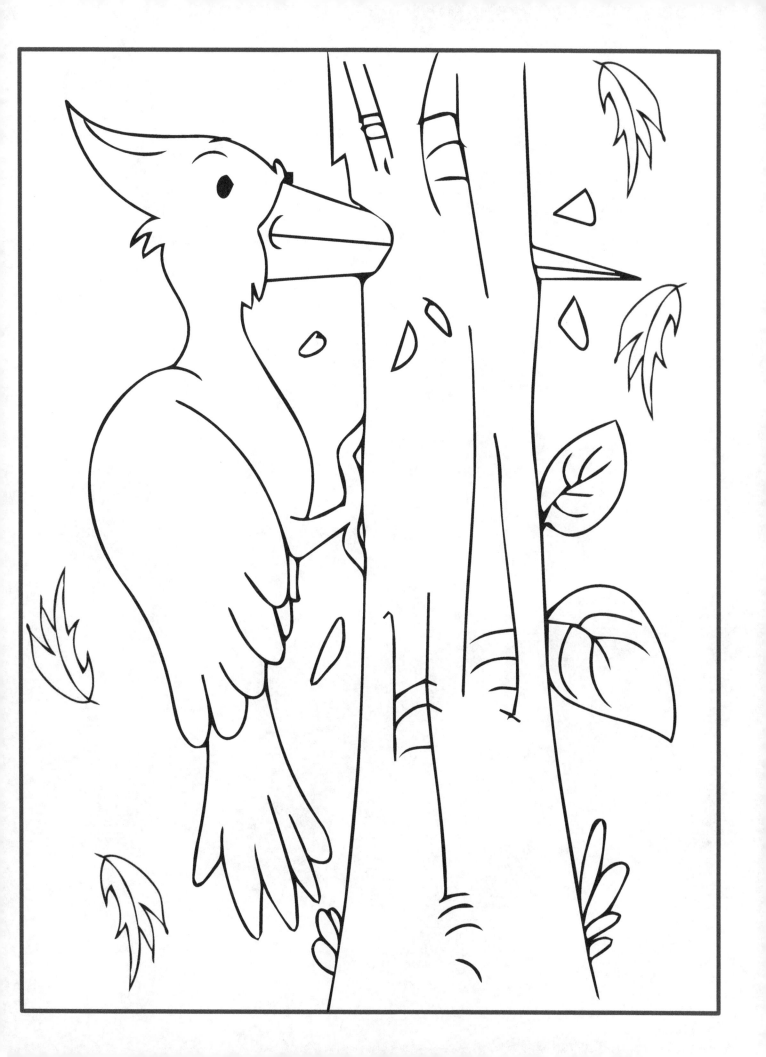

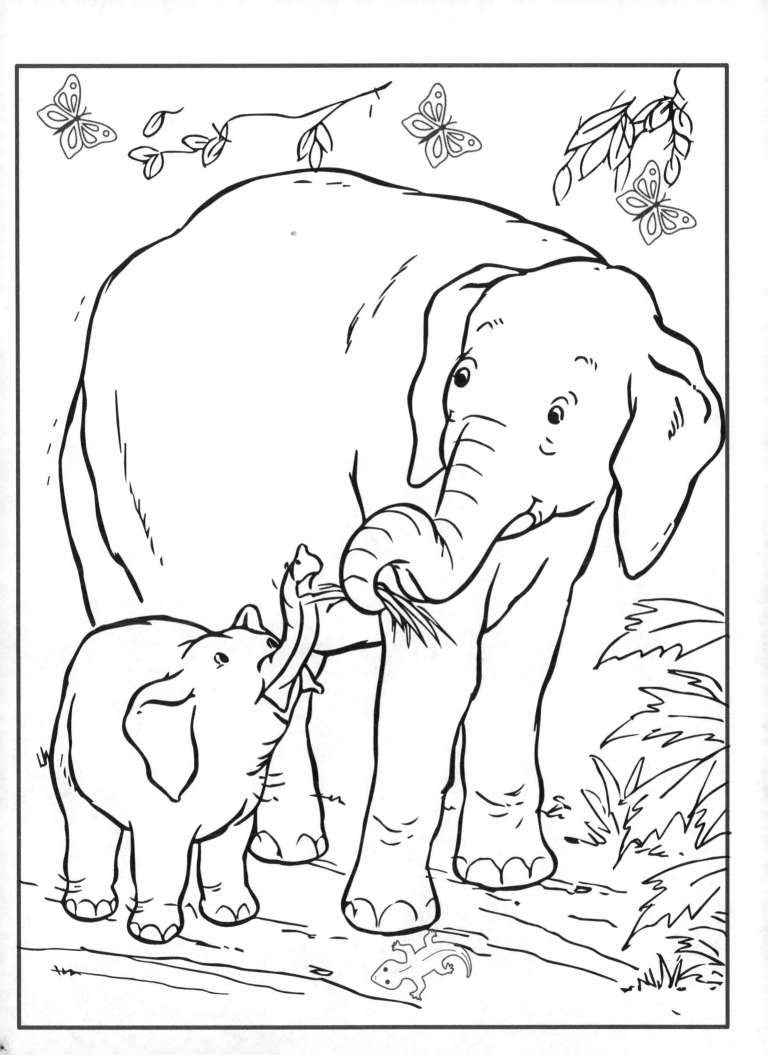

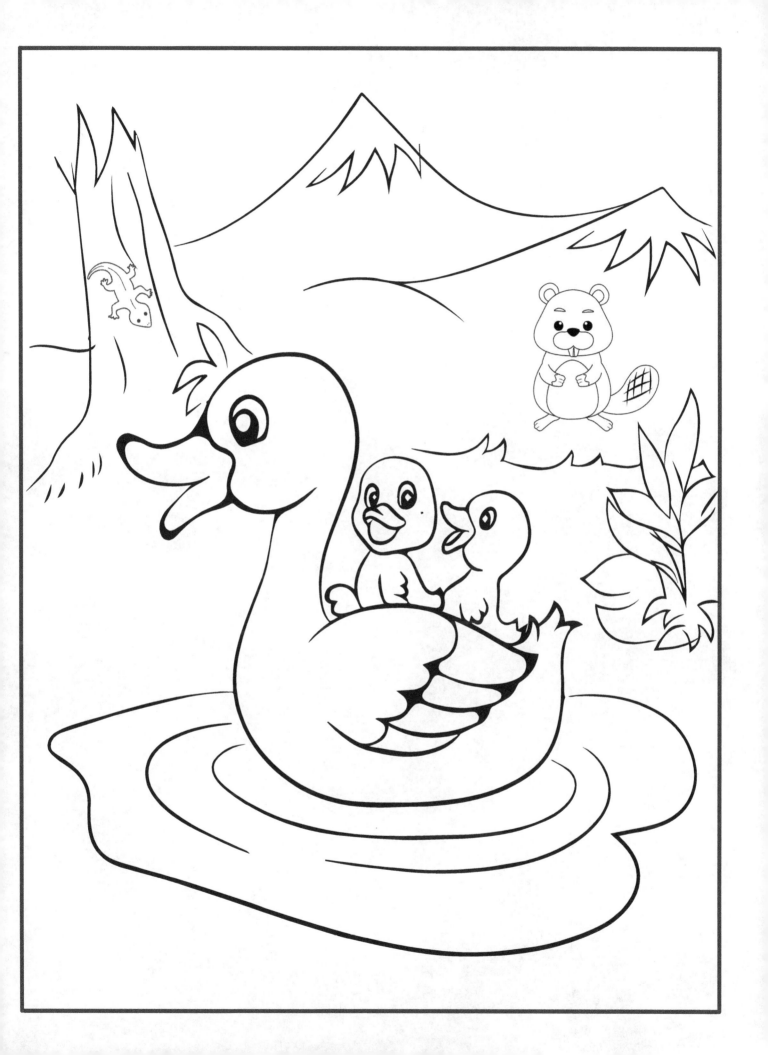

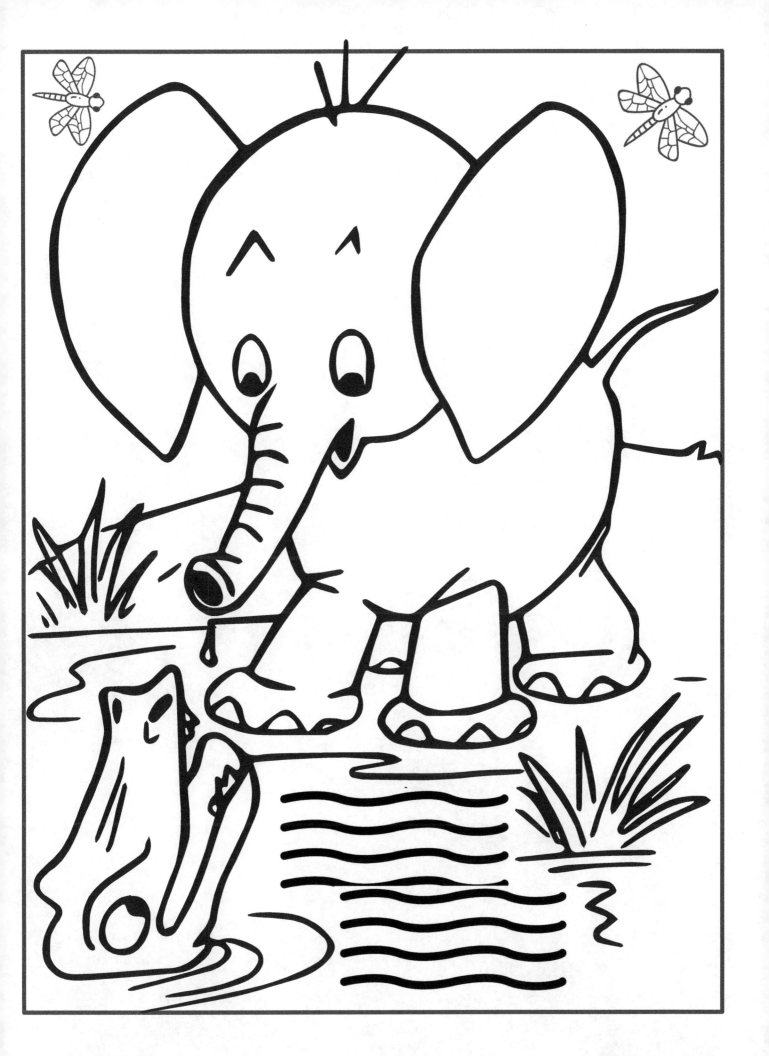

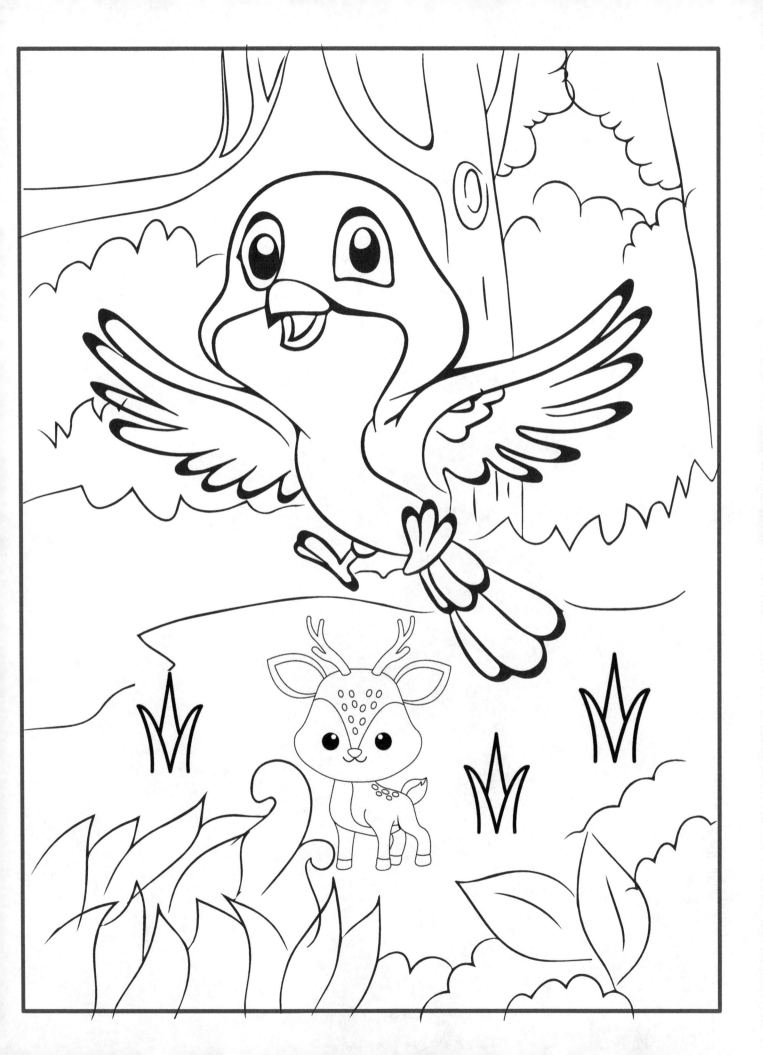

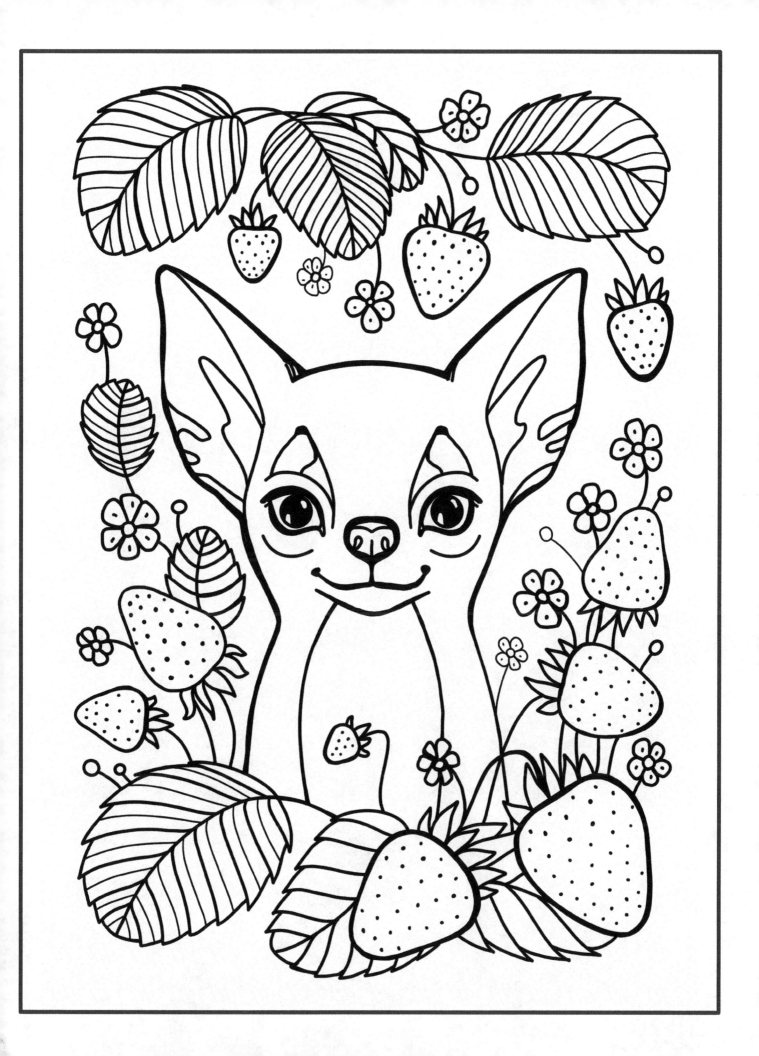

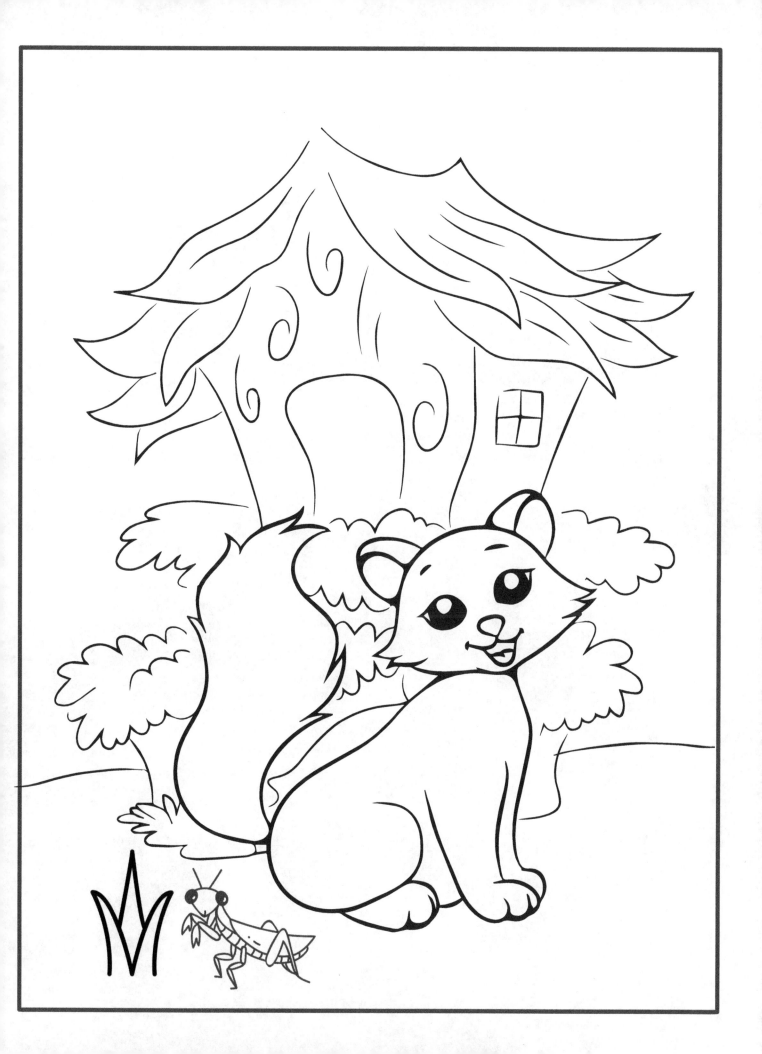

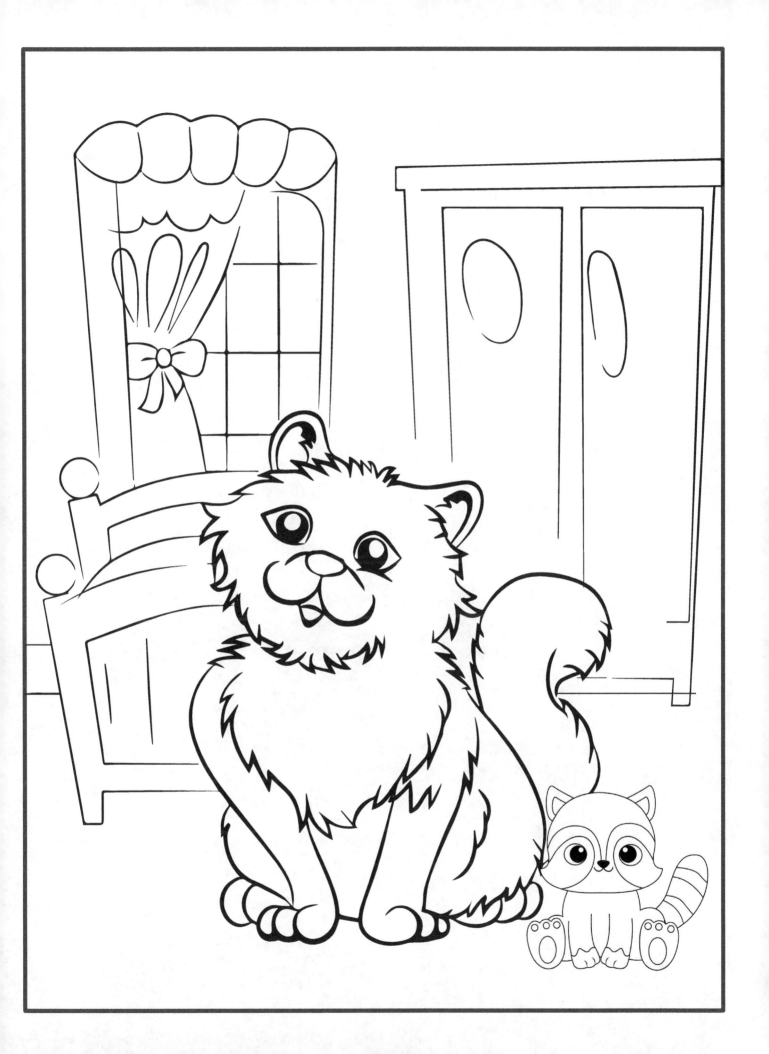

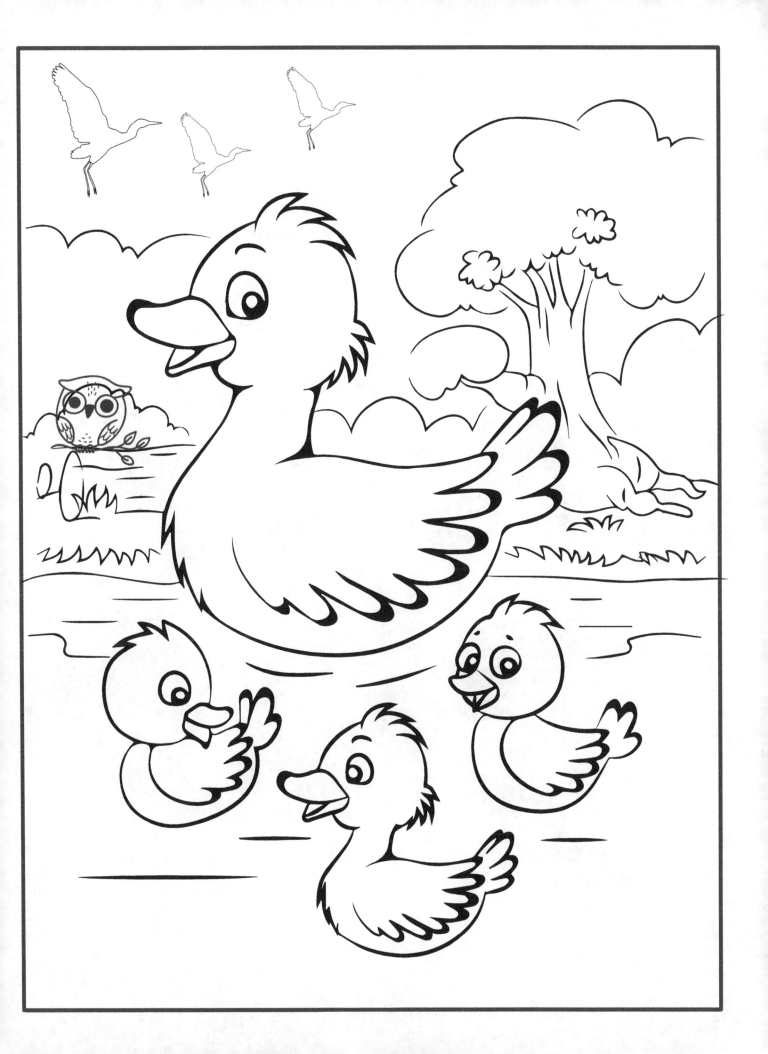

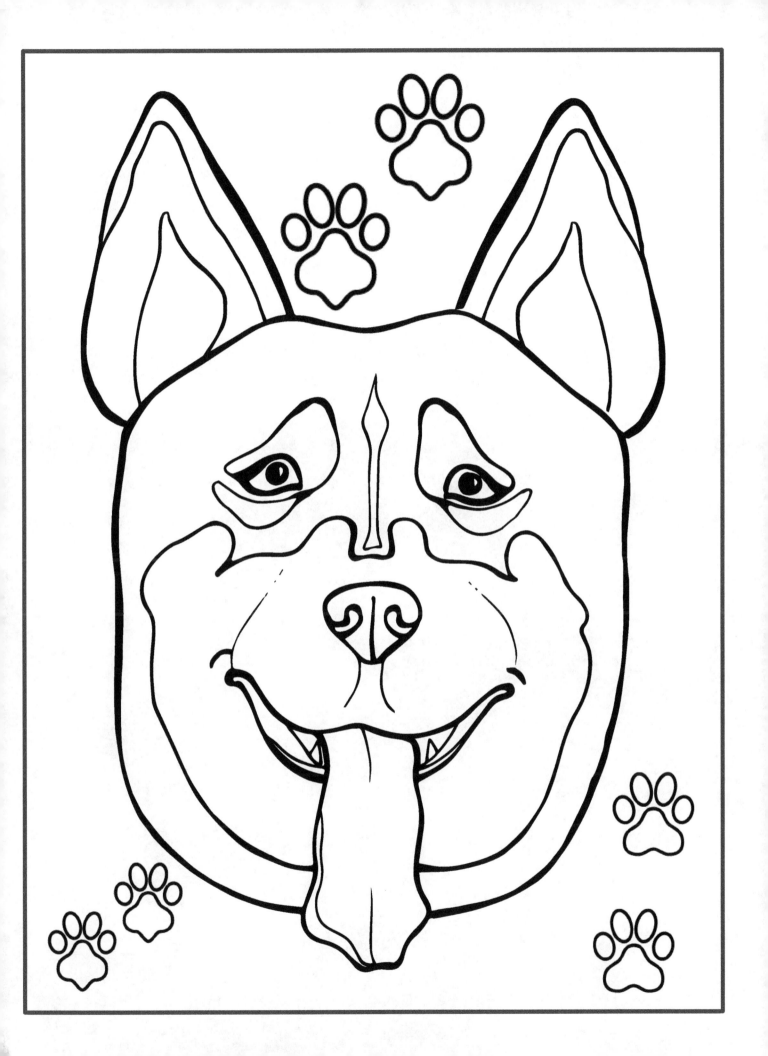

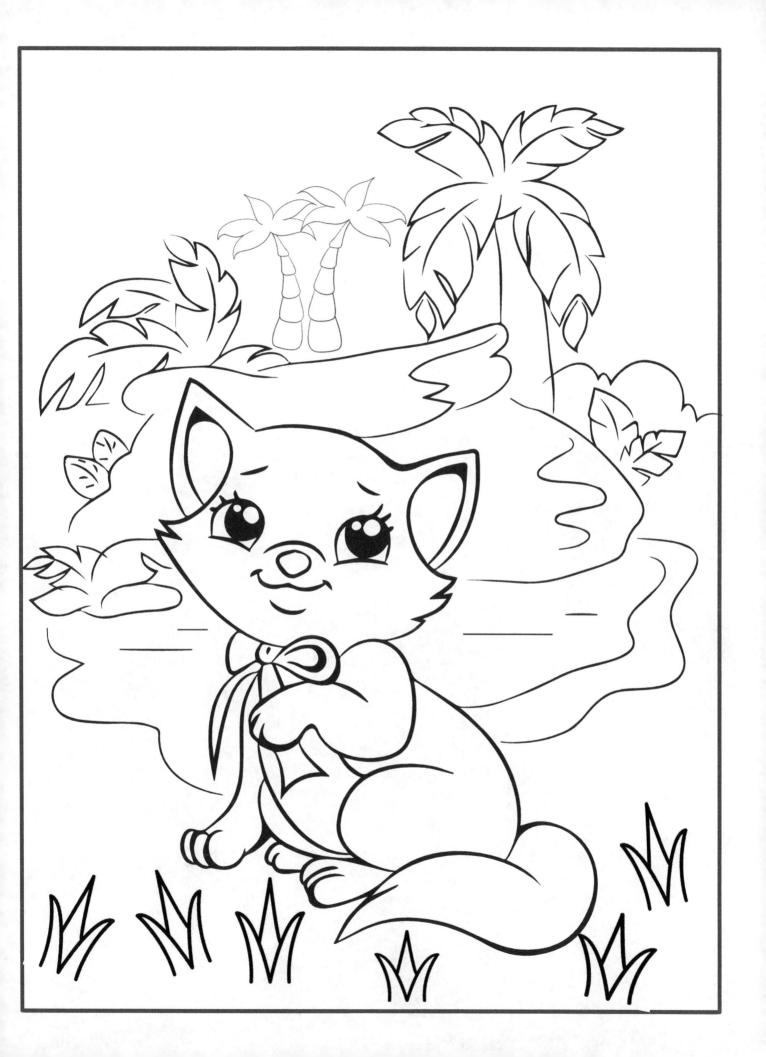

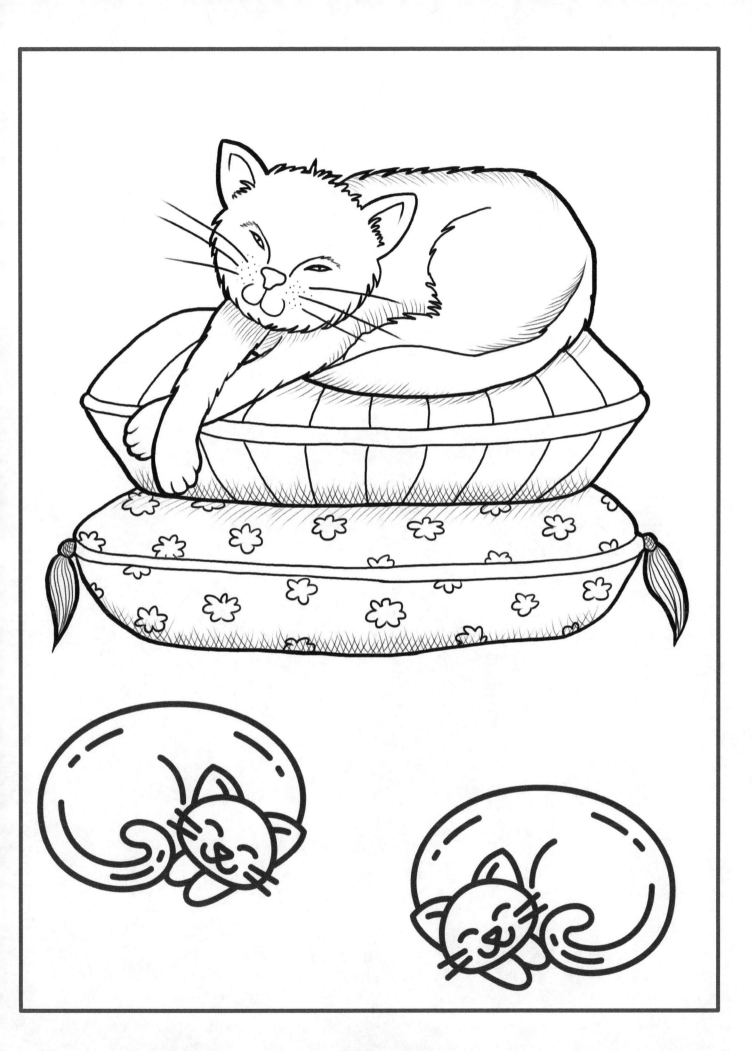

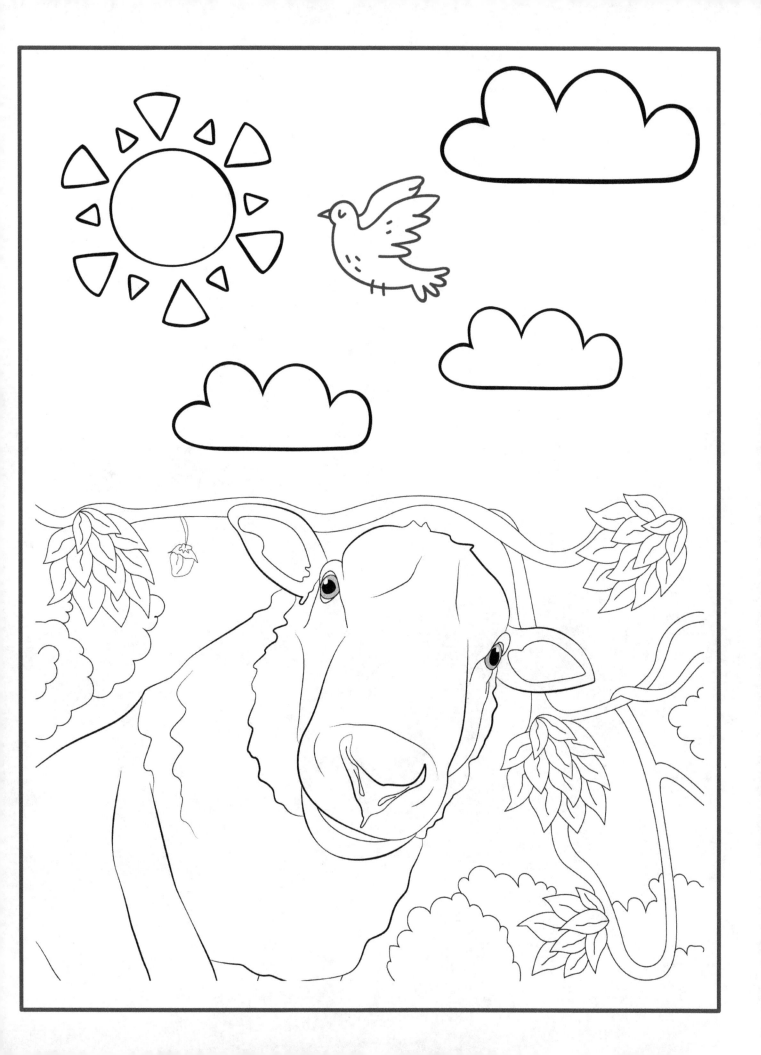

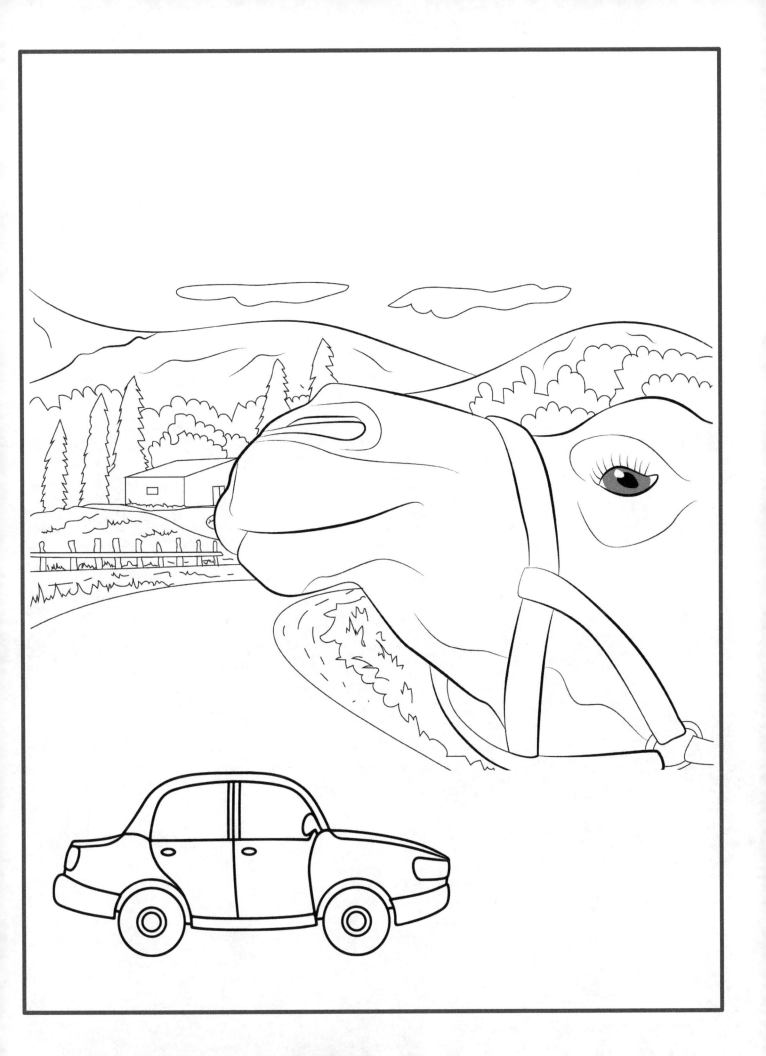

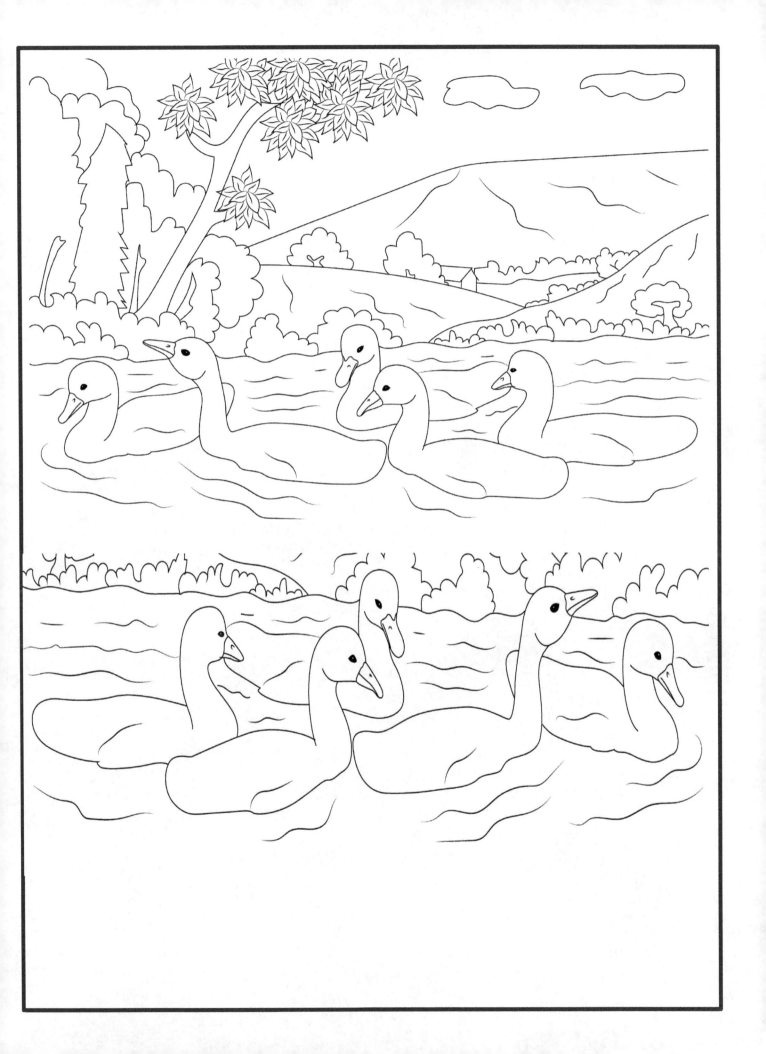

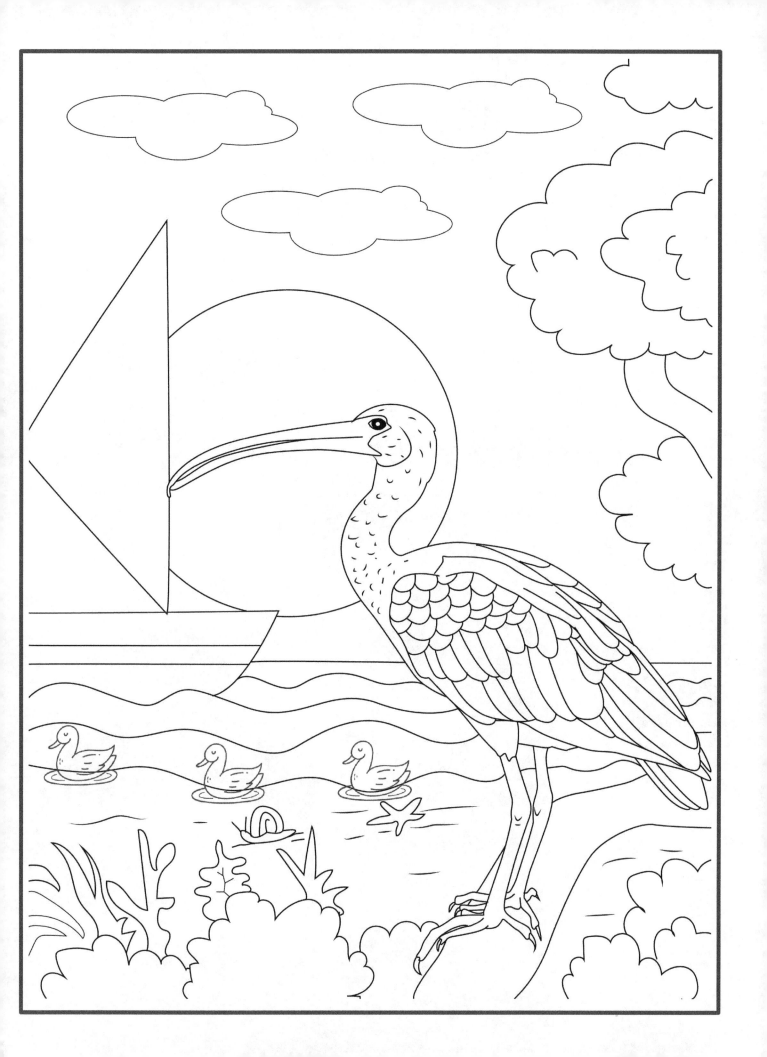

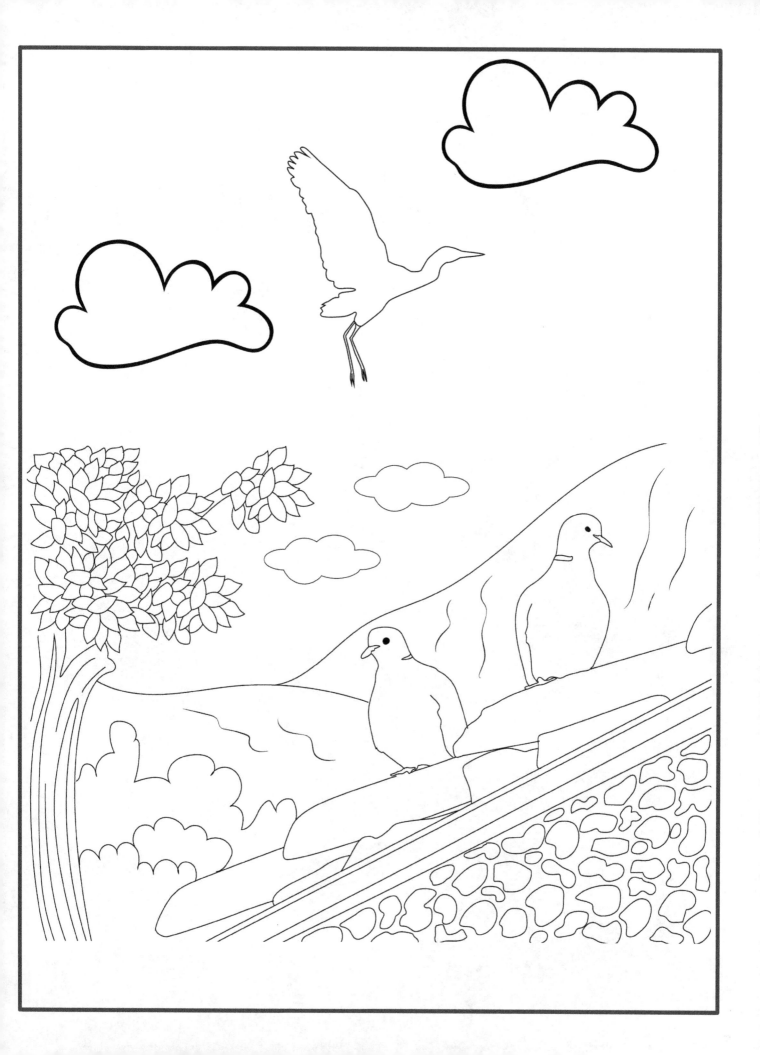

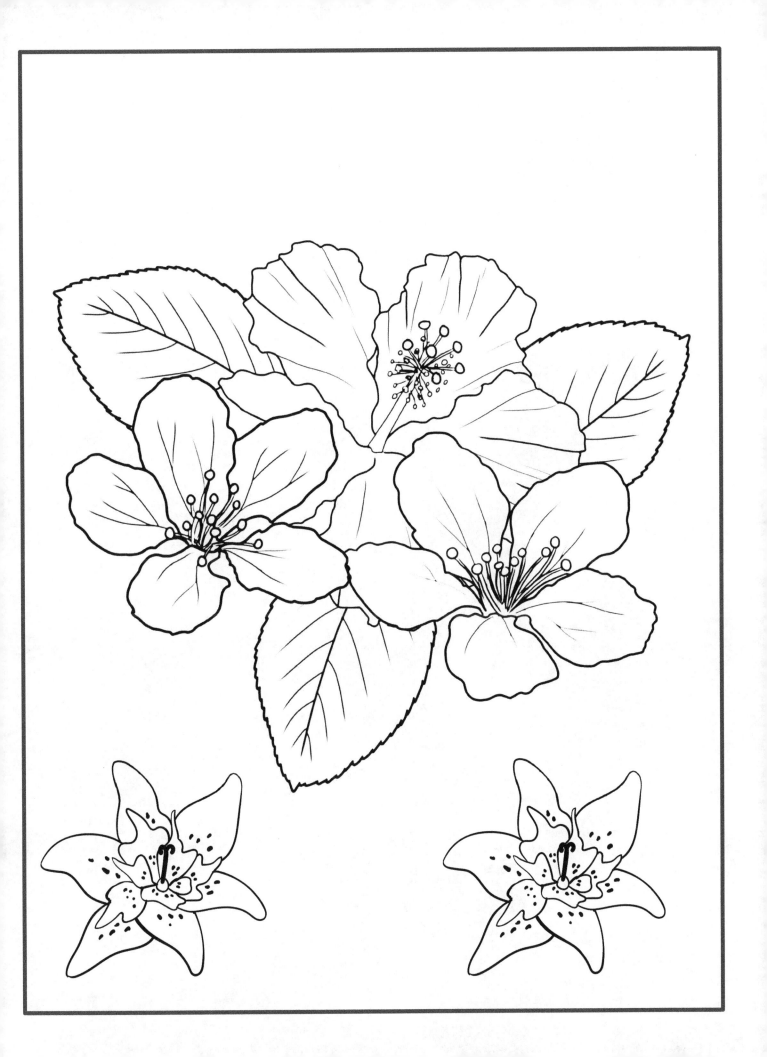

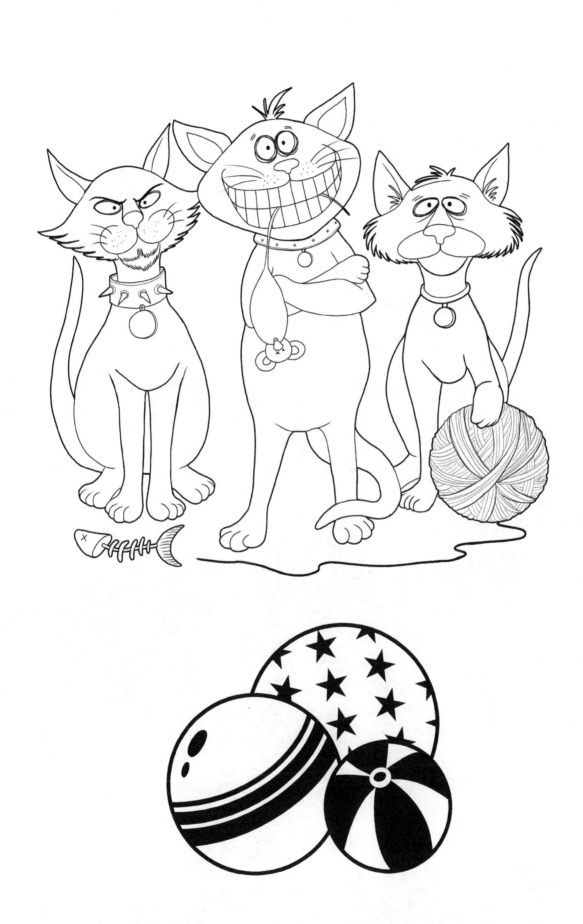

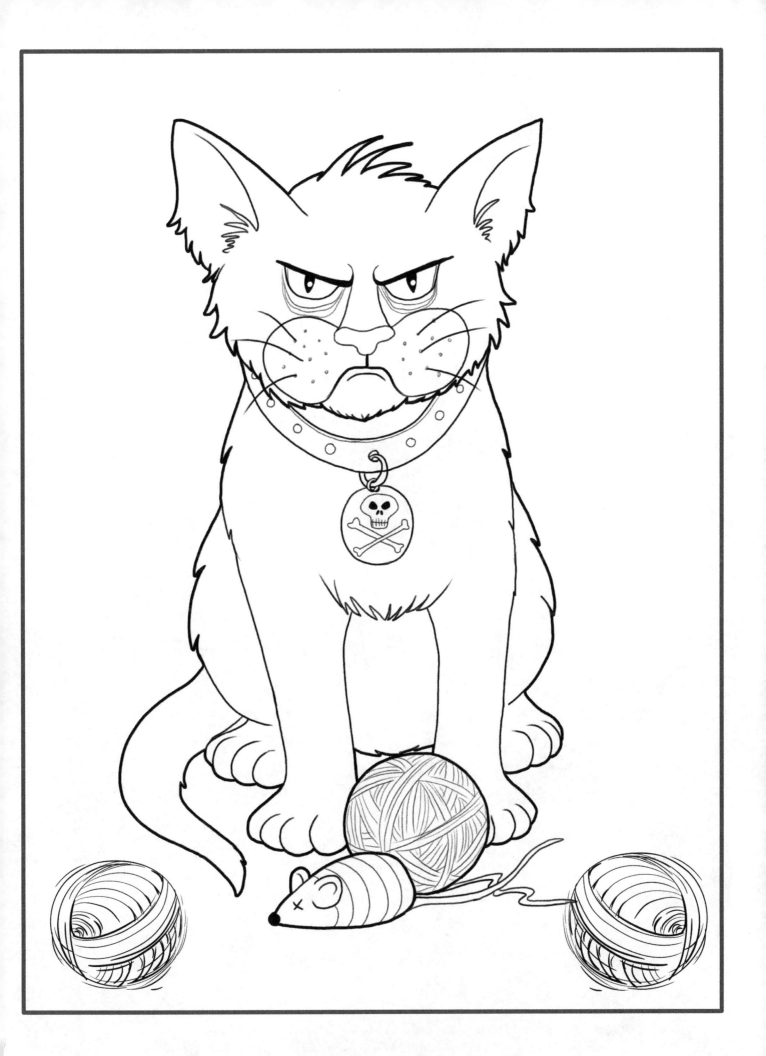

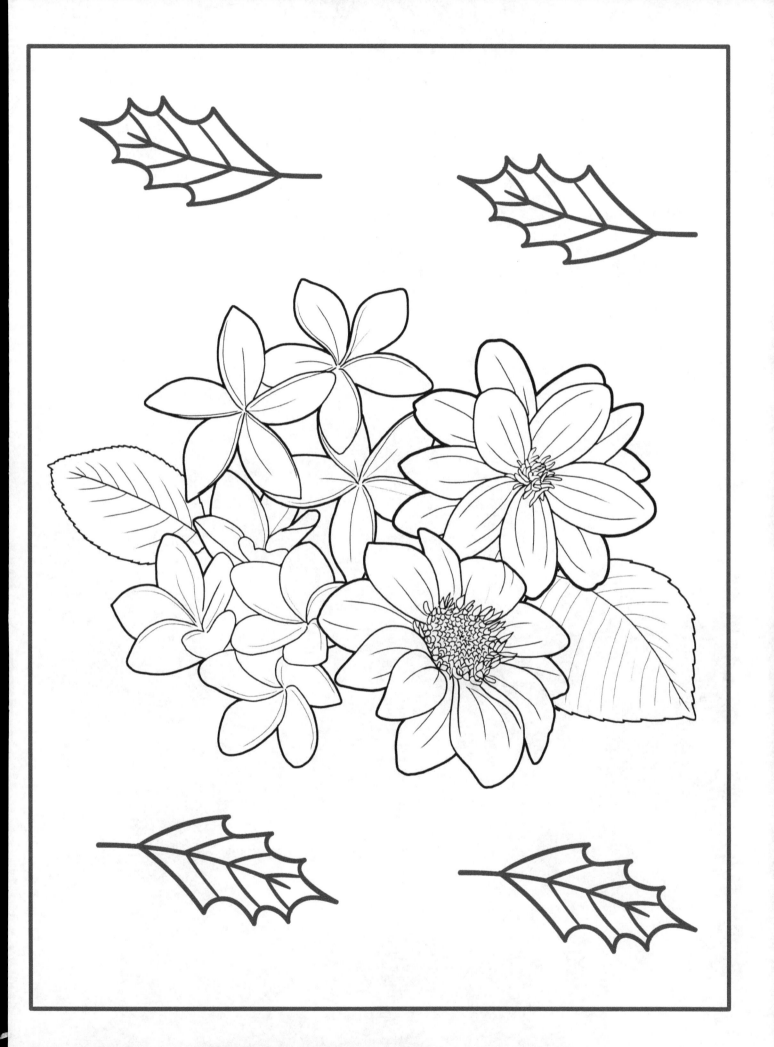

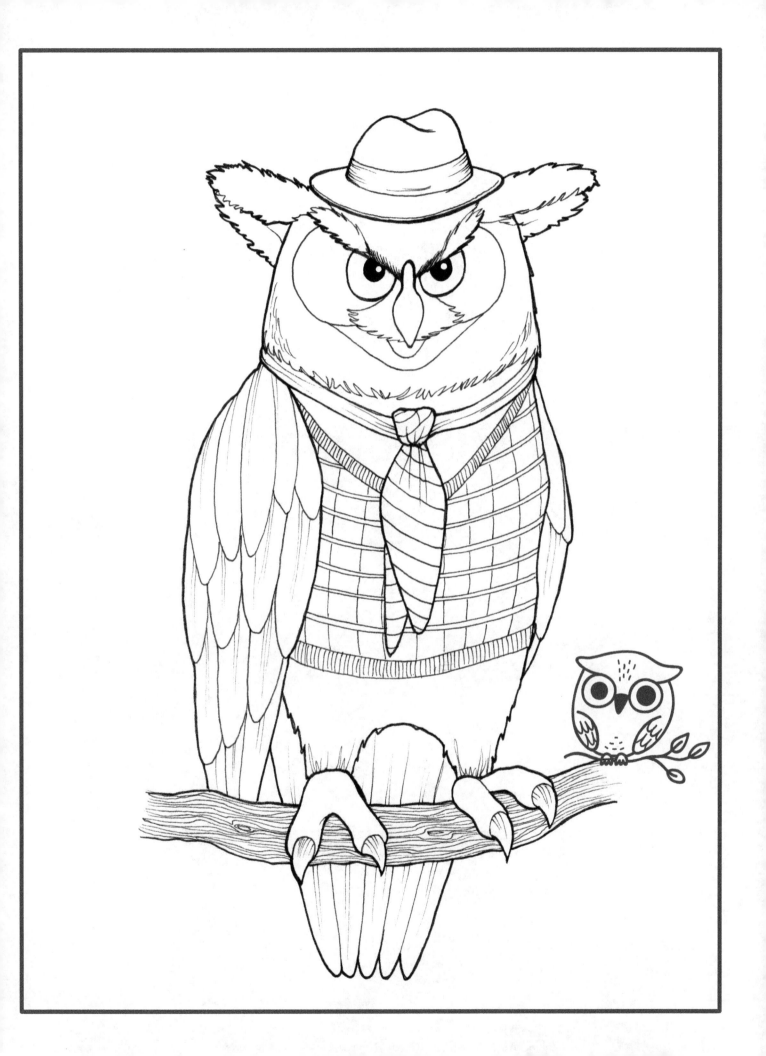

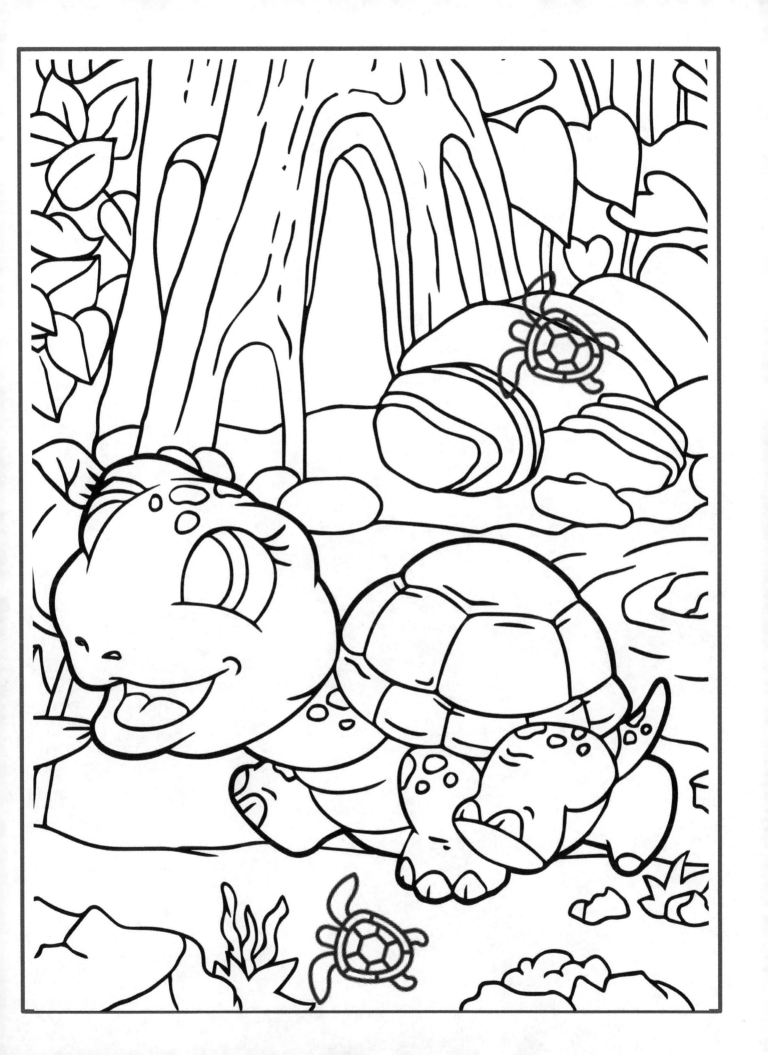

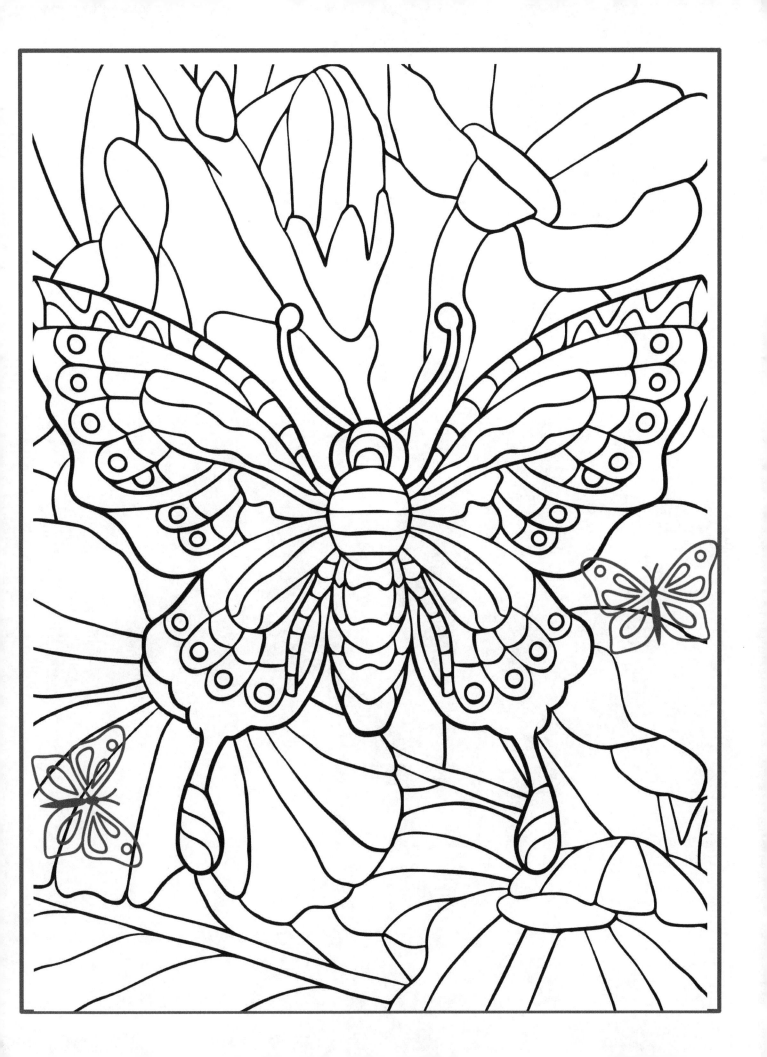

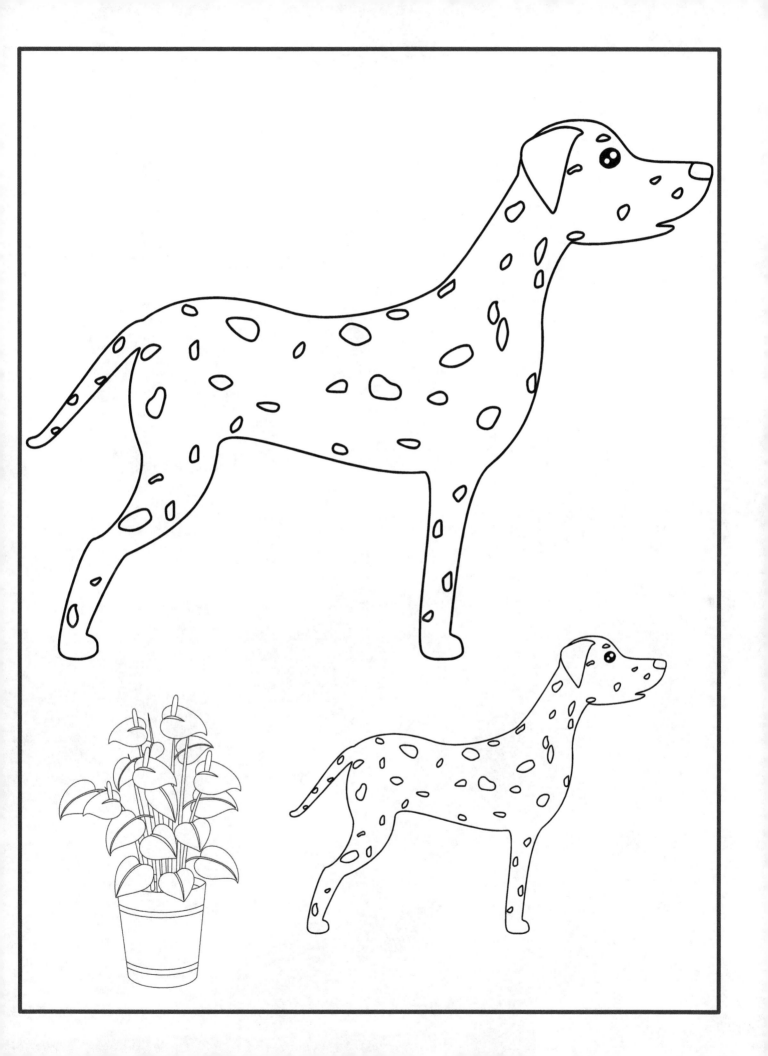

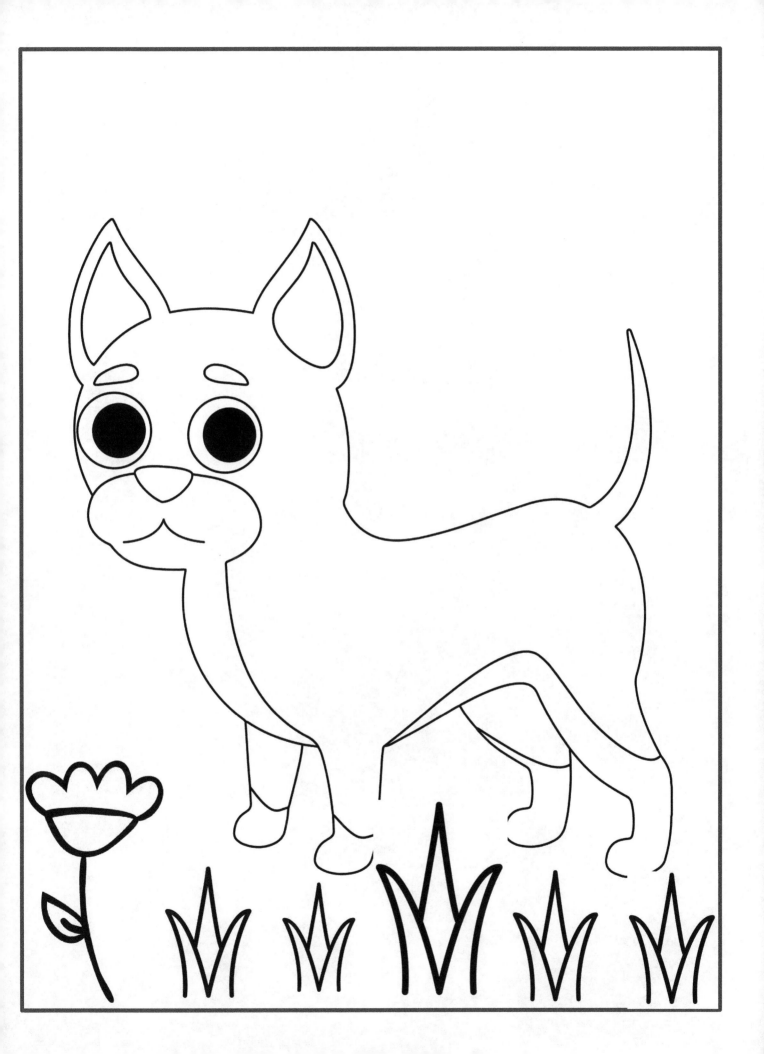

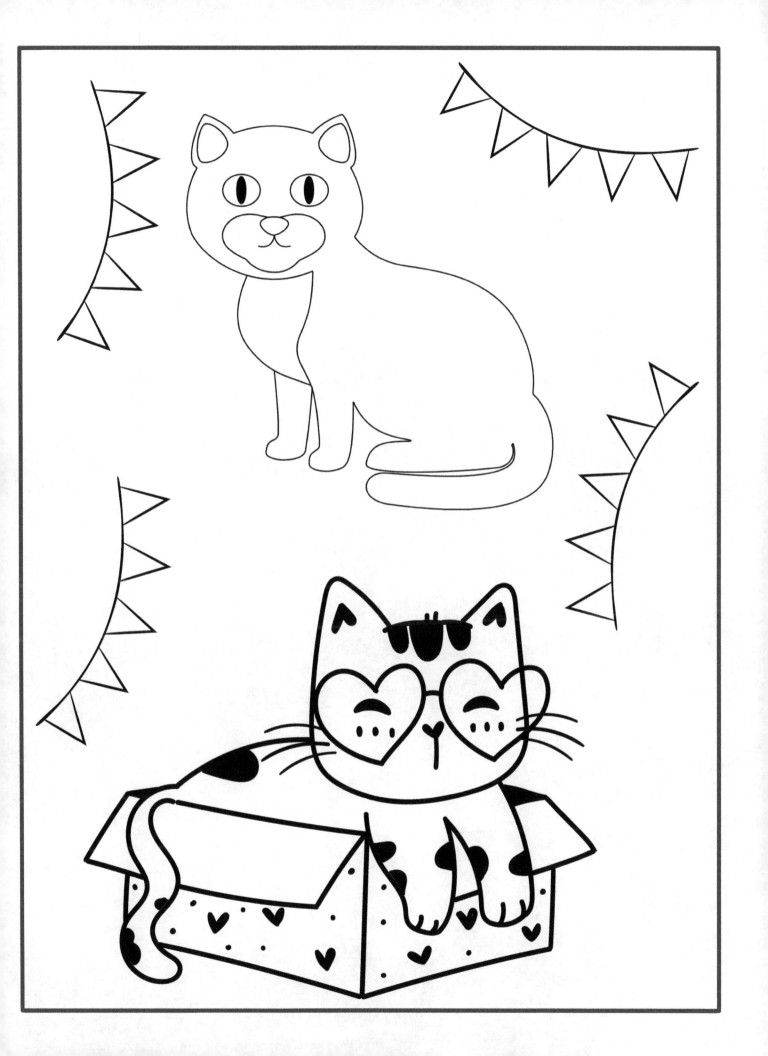

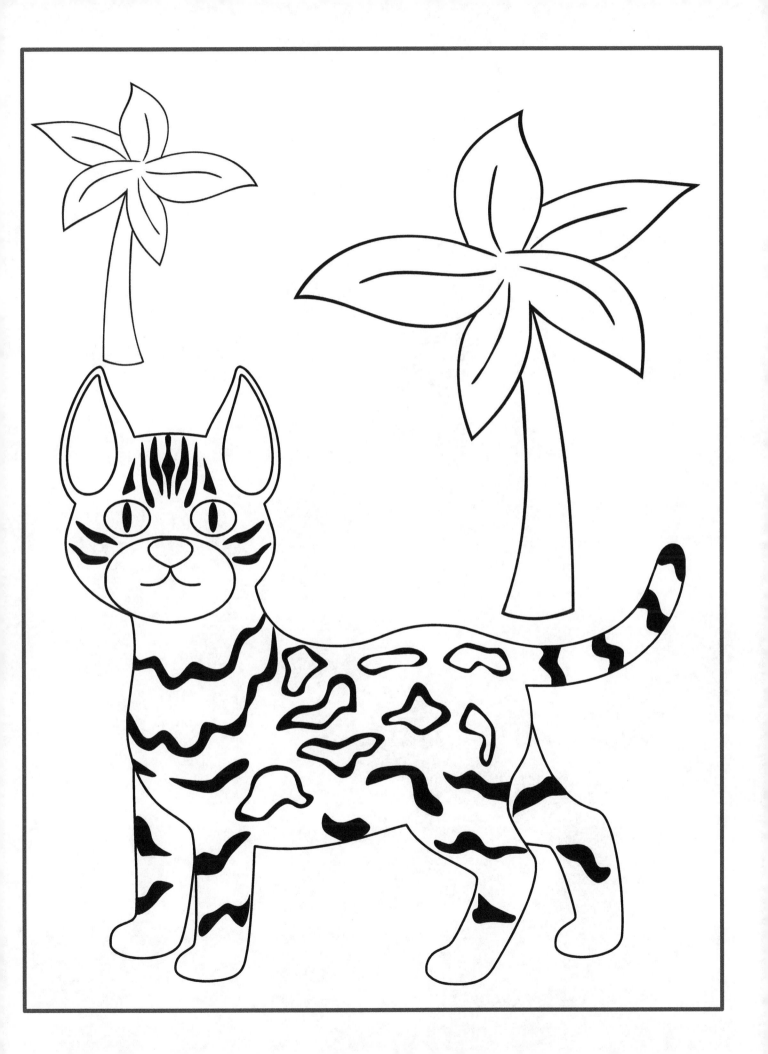

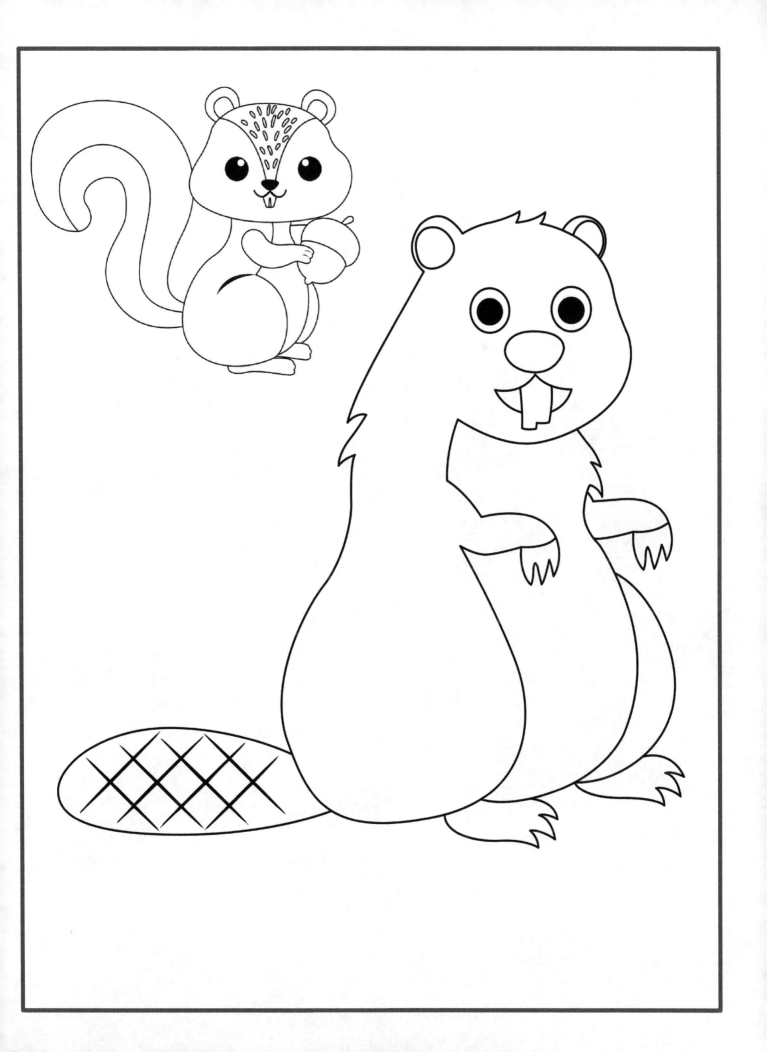

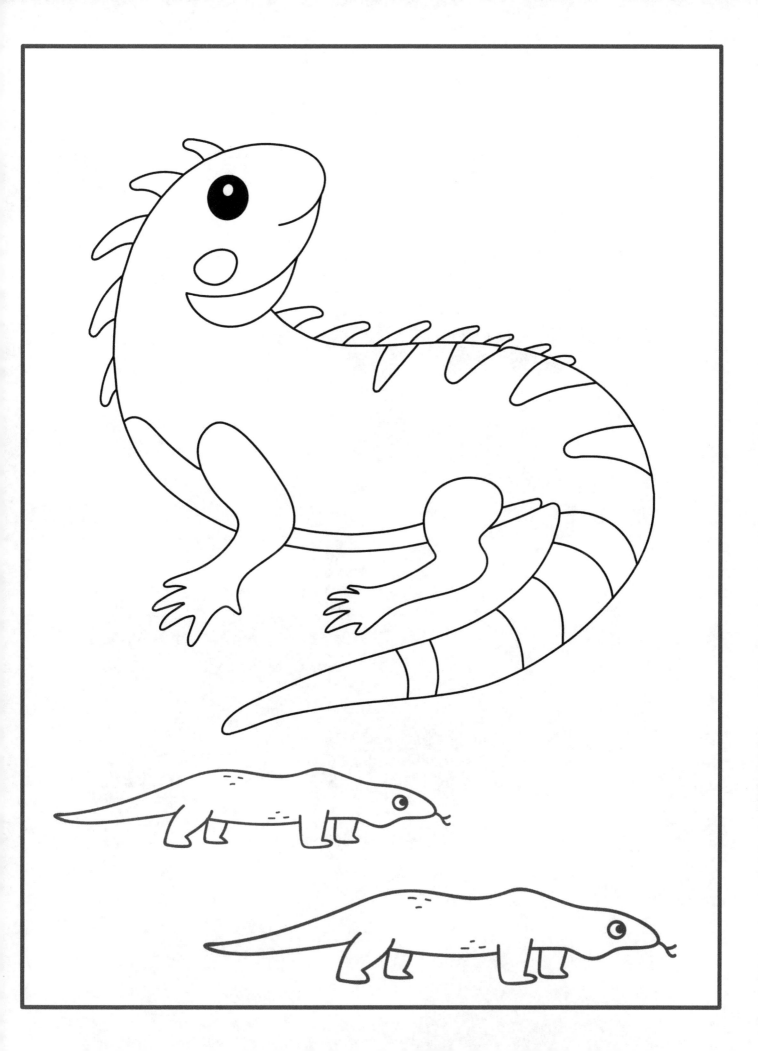

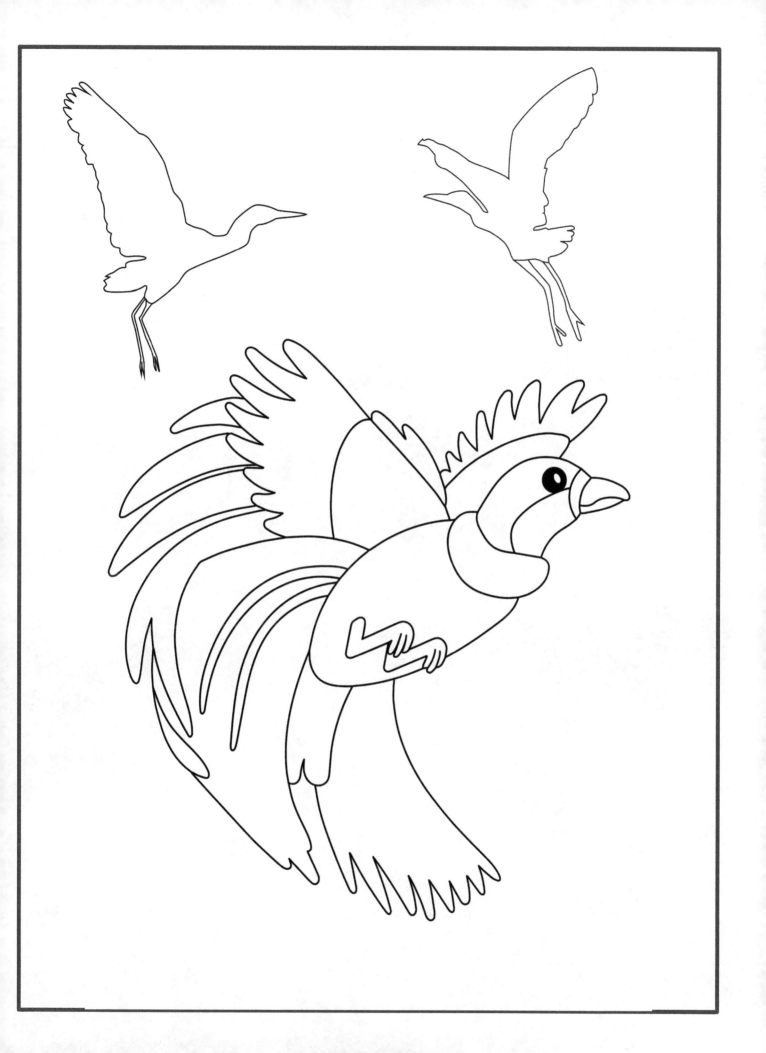

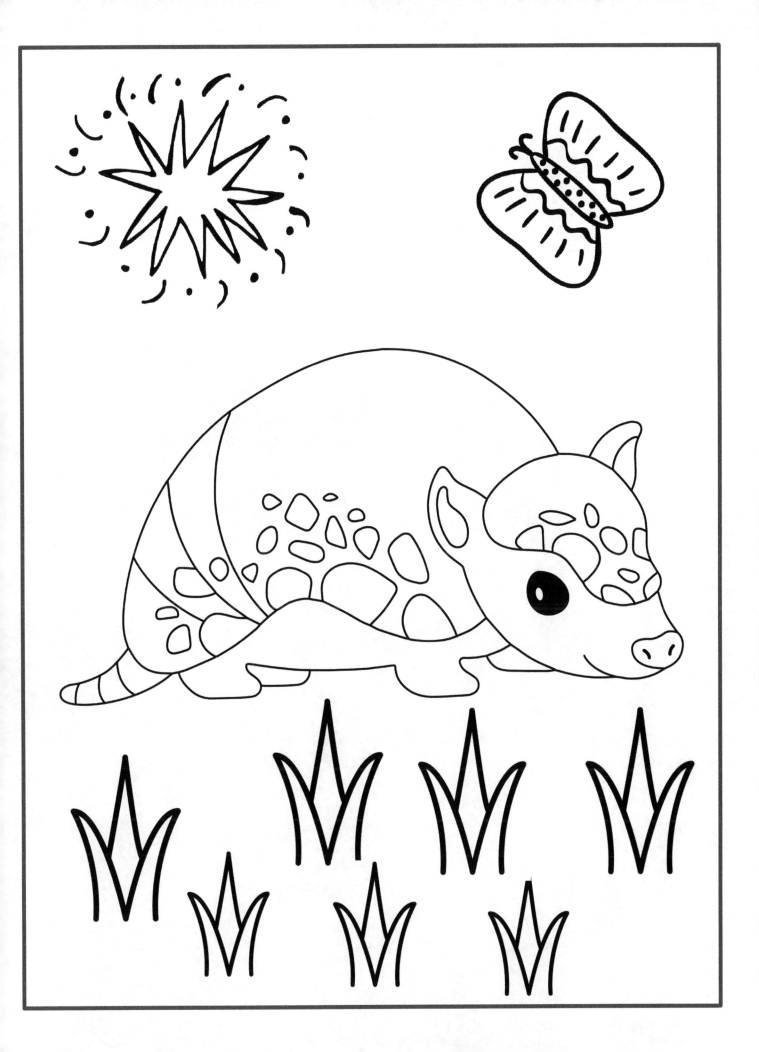

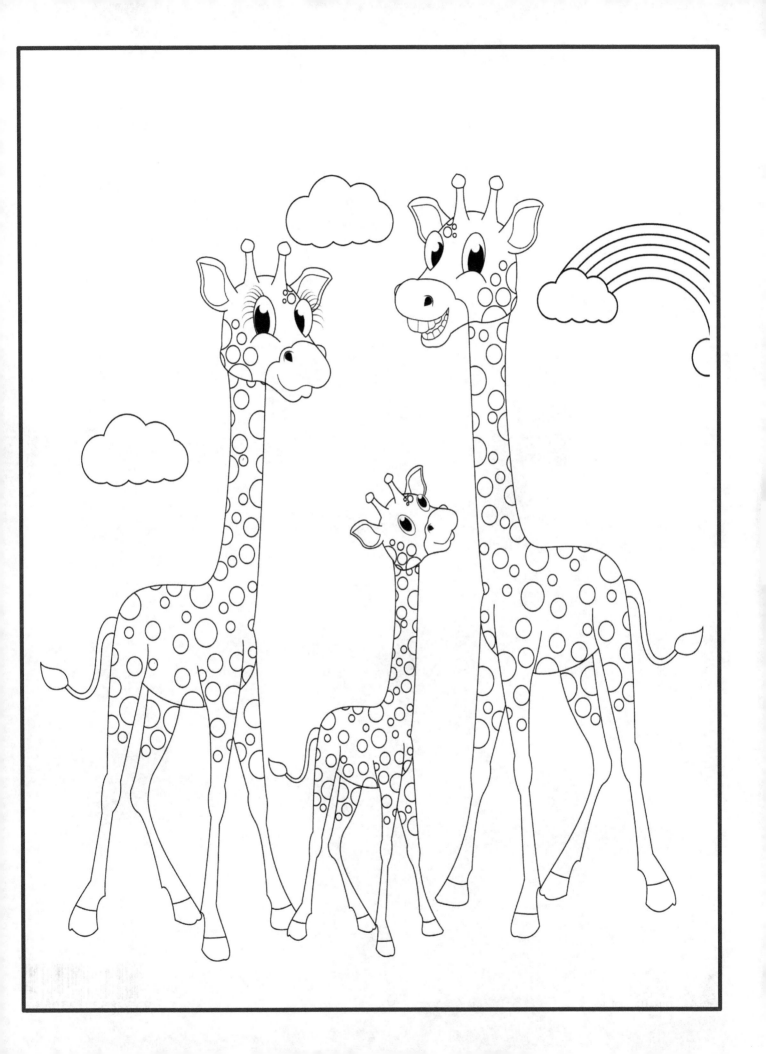

CPSIA information can be obtained
at www.ICGtesting.com
Printed in the USA
LVHW050818180223
739841LV00013B/576